Is Modeling For You?

The HANDBOOK and GUIDE for the YOUNG ASPIRING AFRICAN AMERICAN MODEL

(Revised Second Edition)

By
Yvonne Rose and Tony Rose

Amber Books

Is Modeling For You?
The Handbook and Guide for the Young Aspiring African American Model
(Revised Second Edition)
by Yvonne Rose and Tony Rose
Published by:
Amber Books
1334 E. Chandler Boulevard, Suite 5-D67
Phoenix, AZ 5048
Phone: 602-743-7211
Email: amberbk@aol.com
www.amberbooks.com

Tony Rose, Publisher / Editorial Director and Editor
Yvonne Rose, Associate Publisher
The Printed Page, Cover Layout & Interior Design

The publication is designed to provide accurate and authoritative information in regard to the subject matter covered. It is sold with the understanding that the publisher is not engaged in rendering legal, accounting, or other professional services. If legal advice or other expert assistance is required, the services of a competent professional person should be sought.

Amber Books are available at special discounts for bulk purchases, sales promotions, fund raising or educational purposes. For details, contact: Special Sales Department, Amber Books, 1334 E. Chandler Boulevard, Suite 5-D67, Phoenix, AZ 85048, USA.

Second Edition © Copyright 2011 by Yvonne M. Rose and Conant B. Rose

ISBN 978-0-9790976-9-0

Library of Congress Cataloging-in-Publication Data
Rose, Yvonne.
 Is modeling for you? : the handbook and guide for the young aspiring African American model / by Yvonne Rose and Tony Rose. -- Rev. 2nd ed.
 p. cm.
 ISBN 978-0-9790976-9-0
 1. African American models. 2. Models (Persons)--Vocational guidance. I. Rose, Tony, 1953- II. Title.
 HD8039.M77R673 2011
 746.9'202373--dc23
 2011023247

"Fabulous" "Outstanding"

"This excellent handbook and guide marks Yvonne Rose's leadership as one of the industry's model authorities for all women of color. When you finish reading this book, you will have the knowledge to use to your advantage."
—Alfred Fornay, Founding Beauty Editor, *EM Magazine; Ebony & Essence Magazine, Beauty Editor and Author, The African American Woman's Guide to Successful Makeup and Skin Care and Born Beautiful – The African American Teenagers Complete beauty Guide; and Co-Author, Ageless Beauty – The Ultimate Skincare & Makeup Book for Women & Teens of Color*

"Yvonne and Tony Rose have provided a road map through the often thorny path that young models tread. Their advice is sensible, practical and also spiritual. Read it, heed it, stay strong and in the race— you will move mountains!"
—Terrie M. Williams, Founder, The Terrie Williams Agency; Author, *Black Pain, It Just Looks Like We're Not Hurting*

"Congratulations on a well-needed book that all those interested in modeling should read to see if they have what it takes to succeed in the industry. A must read."
—Dee Simmons, Former Director, Grace Del Marco Modeling Agency

"Pursuing a career in modeling becomes easier when you read this book. Yvonne Rose and Tony Rose share their heart and give great insight into the mysterious world of modeling."
—Ionia Dunn-Lee, Fashion Stylist, Editor, and Educator

"I feel that it's about time for our black models to have a book to read that gives them a direction. This handbook should be sought after—it is well needed!"
—John Blassingame, Founder, New Day Associate's International Model of the Year and International Designer of the Year

"Fabulous!!!! Yvonne and Tony Rose give detailed information on breaking into the competitive world of modeling. This book is a must have for anyone serious about pursuing a modeling career in print, runway or commercial modeling."
—Therez Fleetwood, Designer, Therez Fleetwood Bridal Collection

Is Modeling For You?

The HANDBOOK and GUIDE for the YOUNG ASPIRING AFRICAN AMERICAN MODEL

(Revised Second Edition)

Dedication

This book is dedicated to the young and
aspiring African American youth.

May your dreams become realities,
your talents thrive, and your successes be numerous.

—Yvonne and Tony Rose

Acknowledgments

First, we'd like to thank God who lives in all of us.

To my dear friend, husband and co-writer, Tony Rose who conceived this project, contributed greatly to its completion and brought it to reality as a successful book for all aspiring models.

Thank you also to those of you who have influenced and contributed to my career in fashion.

—*Yvonne Rose*

To Yvonne, who proves that models are forever unique, and creative, as well as beautiful (mi amore).

—*Tony Rose*

Table of Contents

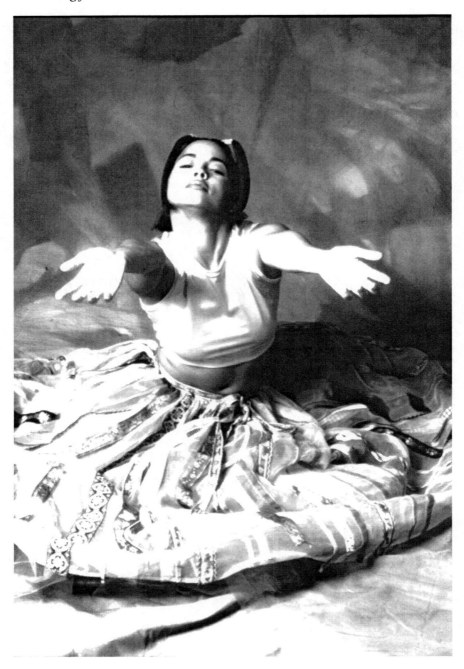

The Model's Creed

Always know that as a successful model, you've got to be totally committed to your career. In your pursuit for a fulfilling modeling career, your spiritual health should always take precedence. And as you journey to the top, reciting "The Model's Creed" will remind you to stay strong and help you to remain on the path.

"I pledge to accept challenges and be the best I can be—
spiritually, mentally and physically.
As I observe my mentors and follow their lead,
I'll continue to absorb knowledge and expand my personality.

I will believe in myself and remain positive-thinking—
for it's up to me to work and make my dreams come true. So if I
do all of these things with faith and conviction, success will surely
follow me my whole life through."

Y.R.

Remember this . . . The pace is fast, furious, and highly competitive! Once you've been accepted into an agency you must put yourself on a good schedule! Get plenty of sleep and exercise! Plan to work at it every day, whether you are on a booking or job, on a go-see or just making the rounds.

NOW LET"S GET GOING!

—Yvonne Rose

Is Modeling for You?

Part I:
Introduction

A Special Welcome

As a former professional model, I've worked with major fashion designers, walking runways and on stage in Massachusetts and New York and Europe, in several of New York's 7th Avenue Showrooms and for several top name boutiques and major department stores throughout the Northeast United States. Later, my modeling experience expanded to teaching at such schools as Barbizon, John Robert Powers and Ophelia DeVore. This led me into fashion commentary and fashion show production. In addition, my credits include motion picture, television and print work. During the interim, which I have described above, I personally met and taught thousands of young people who wanted to learn the details of modeling. Many of my students have graced international runways and appeared on magazine covers, television shows and in films. With so many questions to answer and so many suggestions to offer, we realized how important it would be to compile the pertinent information that could contribute to the success of so many other young aspiring models.

This book was first conceived as a guide to aspiring models who were competing in a modeling and talent pageant. As a judge, I also had the opportunity to hold a series of self improvement seminars, which were intended to add to the career development of those young people who participated.

Upon noting the benefits of such a model's guidebook, my husband Tony Rose encouraged me to expand on the details and offer more definitive information to the ever-growing population of aspiring models. Thus, we took it to another level, conducted interviews, researched pertinent agency information, compiled facts, updated

material and wrote the "ultimate" how-to book for the young aspiring African American model.

My fashion industry experiences and responsibilities as a make-up artist and fashion stylist for television shows, as a print, commercial and runway model; as an actress for soaps and films; fashion show producer, coordinator and commentator; as a modeling and personal improvement instructor; a fashion buying, marketing and management teacher; as a pageant coordinator; a public speaker; Senior Vice President of Edgar Morris, Inc., an international corrective skin care company, President of Rose Beauty Network, an international health and beauty products distribution company; and currently Associate Publisher of Amber Communications Group, Inc. have enabled me to touch the lives of thousands of young people.

Our purpose has been and always will be to enhance the lives of those that we touch through seminars, fashion shows, workshops, private instruction and personal management. It's up to you to make your dreams become realities. Accept challenges and be the best you can be. Absorb knowledge, observe people, develop your talents, and be posi-tive....if you do all of these things, success will inevitably follow you. We look forward to "Your" success!

—Yvonne Rose

Supermodels Defined

A History of African American Models and How They Made it to the Top

The term **supermodel**, coined in the 1980s, refers to a highly-paid famous and successful élite fashion model who usually has a worldwide reputation and often a background in haute couture and commercial modeling. The most prominent criterion for being named a supermodel is that one must have some sort of celebrity status The term took hold in the popular culture of the 1980s and 1990s. Supermodels usually work for top fashion designers and labels. They have multi-million dollar contracts, endorsements and campaigns. They have branded themselves as household names and worldwide recognition is associated with their modeling careers. They have been on the covers of various magazines, and particularly they must be on all the covers all over the world at the same time so that people can recognize them. First-name recognition is a solid indication of supermodel status in the fashion industry.

Naomi Sims was the Wilhelmina Modeling Agency's first African American model and the first African American supermodel **Beverly Johnson** is the first African American woman on the cover of fashion bible VOGUE. **Tyson Beckford**—1st African American male to be signed a multi-million exclusive contract with Ralph Lauren. **Tyra Banks** is widely known as one of the most famous fashion models of the world and one of the original Victoria's Secret's angels. Tyra was also the first African-American model to be featured on the covers of GQ and the Sport's Illustrated's swimsuit issue. **Naomi Campbell** was the

first black cover model for French Vogue Paris and the European edition of Time magazine. In 1991 **Veronica Webb** became a spokesmodel for Revlon, making her the first African American supermodel to win an exclusive contract for a major cosmetics company. **Lana Ogilvie**—the first African American model to sign an exclusive contract with Cover Girl face and skin care products.

In 1955, top African American models earned $35 an hour. In 1970, they earned $1000 per week. In the nineties, an African American super model earned $2 million and up per year. In 2010 supermodels of all ethnicities reportedly were earning about $5 million a year.

What makes these models so special and in demand? Well, besides their courage, beauty, stamina, and poise, they all dedicated themselves to hard work, discipline, a determination to succeed, and eventually, they all signed with strong modeling agencies.

Anyone attempting to enter the modeling industry will tell you that becoming noticed by top agencies seems virtually impossible. The world of modeling can often be quite cold and ugly, with only a selected few being singled out for large campaigns and jobs. Surprisingly, the qualities that one had to have in the 70s, 80s and 90s to be a "supermodel" aren't much terribly different than those one must have today. But there are some interesting reasons why this title is rarely bestowed on models currently in the business.

Models are no longer required to be "pretty." The concept of what a model should look like has changed drastically over the years. At one time, blue-eyed blondes were all the rage. Eventually, the world came to appreciate glamorous brunettes and eventually more attention turned to African-American models. The conditions for being a model were typically stringent, with ladies being required to adhere to strict physical proportions, while retaining their feminine curves. But over time, these standards evolved, and the subtle curves gave way to jutting hip bones, spindly legs, and bony shoulders. The faces once full of vigor, mischief, and seductiveness, began giving way to blank stares and disaffected expressions. In fact, the models strutting down catwalks in the years

following the Supermodel 90's have been conventionally less "pretty" than their predecessors. Designers and agents began celebrating many different types of beauty. Models with unusual and exotic features started popping up on runways across the world. This served to be encouraging to the masses, as it allowed many more traditional looking women to enter the market and become successful—thus trimming away the notion of the "Supermodel."

The African American models and "top models" of today are responsible for hundreds of millions of dollars of the advertising and editorial profits made from the billion dollar modeling industry. In this introductory section, you will get to know some courageous and beautiful models who paved the way and some models you might know who continue to reign at the top of the industry.

Paved the Way:

NAOMI SIMS—a name that everyone recognizes. She was the Wilhelmina Modeling Agency's first African American model and the first African American supermodel. She was teased for her height of 5'10 at age 13, but her grace on the runway led her into a lucrative modeling career.

Her first big break came when she was photographed for the New York Times Magazine "Fashion of the Times". The Pittsburgh, PA native was the first African American model to appear on the cover of a national magazine "Ladies Home Journal". By the early seventies, Naomi had changed agencies, becoming a Ford model. Since then, she has maintained strong visibility from the many covers on which she appeared, including Ebony, Essence, Cosmopolitan, McCalls, and Life Magazine.

Sims ultimately decided to go into the beauty business for herself. In 1973, she retired from modeling to start her own business which created a successful wig collection fashioned after the texture of straightened African American hair. It eventually expanded into a multimillion-dollar beauty empire and at least five books on modeling and beauty, including: *All About Health and Beauty for the Black Woman, How to Be a Top*

Model and *All About Success for the Black Woman*, as well as an advice column for teenage girls in *Right On!* magazine.

Naomi Sims died of breast cancer on August 1, 2009.

IMAN—one of the top three world's greatest supermodels—an original, a legend in her own lifetime. Out of Africa, she was discovered in Somalia by a photographer and brought to America. She became an instant sensation through hard work, good work habits, strict exercise and discipline. Iman's career has spanned two decades and is still going strong. Married to music sensation David Bowie, she travels the world on behalf of many charitable organizations promoting goodwill. Iman who has been and remains one of the world's most recognizable faces is also the originator of the very popular "Iman" Cosmetics Line.

BEVERLY JOHNSON—a champion swimmer who hails from Buffalo, New York. She became an instant celebrity as the first African American model to appear on the cover of Vogue magazine in 1974. Her recognition as one of the world's most beautiful women helped open the doors for other African American models to work for major designers and publications. This very successful former Wilhelmina model has more that 500 magazine covers and fashion spreads to her credit.

PAT CLEVELAND's story is one that every young aspiring African American model dreams of. As an aspiring designer, Pat studied at Fashion Institute of Technology in New York. She always dressed fashionably and stood out in her own designs. On her way home from school, Pat was discovered at the age of fifteen, by a Vogue editor. She was immediately booked for her first modeling assignment to do a fashion spread for the magazine. While hanging out in the fashion circles, Pat met designer Stephen Burrows and became one of his models. During the same year, Pat got booked to do the Ebony Fashion Fair tour. She was moving fast and quickly went from Elite to Wilhelmina; and shortly thereafter, Pat was on her way to Milan where she would become one of the world's supermodels and a partner of Elite Runway in Milan.

SHEILA JOHNSON—a native of Boston, Massachusetts. Upon finishing high school, Sheila headed to New York to begin an acting career. She was immediately discovered and began professional runway modeling. She also began doing print work including several magazine covers, editorial and fashion layouts, catalogue work, and product advertisements for companies such as Virginia Slims, Smirnoff and Cover Girl. Sheila's acting career began with an appearance in "Coming to America" and continues to flourish.

ALVA CHIN—from Boston, Massachusetts. She made up her mind to become a model and went to New York in pursuit of designer Stephen Burrows. Getting booked to model for Burrows opened up the door to an international career. Alva did extensive catalogue work in the 80's and she got booked as a famous "Charlie" girl. Her highly successful modeling career has expanded to include several film and television credits.

Continuing the Reign:

TYRA BANKS—certainly the most assessable supermodel of today. Tyra's rise to fame and fortune is a must-study for any aspiring model. Discovered while attending Hollywood High School by photographer Carolyn Johnson and encouraged by her mother, Tyra at an early age discovered the ways of becoming as one with a camera. She read books and studied hard at posing and learning the dozens of facial expressions that can help that up-and-coming model get that all important job. By careful exercise, determination and dedication to her skills, Tyra emerged as today's newest, freshest, most in-demand photographed model on the scene. She is a must-study and role model for any aspiring dedicated model. Upon moving to Paris at age seventeen, within two weeks, she became cover girl on a top French magazine. Shortly thereafter, Tyra became the rage of that year's Paris fashion shows, working the runway with major designers such as Oscar de La Renta, Chanel, Yves St. Laurent and Karl Lagerfield. Soon Tyra graced the covers of Vogue, Cosmopolitan and Elle. Within months, Tyra had become the hottest new model on the fashion scene. She first became famous as a model in Paris, Milan, London, Tokyo, and New York, but television appearances were her

commercial breakthrough. Banks is the creator and host of the UPN/ The CW reality television show *America's Next Top Model*, co-creator of *True Beauty*, and host of her own talk show, *The Tyra Banks Show.*

NAOMI CAMPBELL—Before Tyra, Veronica and Beverly Peele, the term "Black Super Model" was penned exclusively for Naomi Campbell. Managed and brought to America from England by her mother—a model herself, Naomi ferociously devoured the New York runway fashion scene, quickly establishing herself as the darling of the International set. Having accomplished fame through hard work, and a fiercely ambitious personality, Naomi continues to appear anywhere there's a television camera, a photographer's lens or a writer's pen. She is a master of media manipulation and should be studied seriously by those up-and-coming models that seek success through image changing.

Campbell started her career in the 1980s. At age 15 and while still a student at the Italia Conti Academy, Campbell was spotted by Beth Boldt, a former Ford model and head of the Synchro model agency, while window-shopping in Covent Garden. Campbell soon opted to become a full-time model, signing with Elite Model Management. Campbell started as a catwalk model and was quickly hired for various high-profile advertising campaigns, including Lee Jeans and Olympus Corporation, which introduced her to the American market. In August 1988, she appeared on the cover of *French Vogue* as the publication's first African American cover girl, after friend and mentor, Yves St. Laurent, threatened to withdraw all of his advertising from the publication after it refused to place Campbell, or any African American model, on its cover. She was also the first African American model on the cover of *Time* magazine (TIME Magazine Europe 9/18/91) and ultimately appeared on over 500 covers of renowned fashion magazines.. Campbell is also known for a number of perfumes associated with her name

VERONICA WEBB—called the "Models' Model". She is one of the great runway catwalkers. She was born in Detroit and went to New York to study art. She was mesmerized by the "Big Apple" and all that it offered in the way of fashion and beauty. To support herself, she worked part-time as a cashier in a store in SoHo and continued to receive advice

from the customers–agents, hair dressers, make-up artists–who advised her to get into modeling. She signed up with Click Agency and got booked immediately for Seventeen and Mademoiselle. Soon she was bitten by the modeling bug, and asked her agent to send her to Paris where she remained for two years where she covered the runways and was featured modeling top designs in all of the fashion magazines. After taking her modeling career to new heights with an exclusive Revlon contract, Veronica took up acting. Her film credits include *Someone Like You...*, *The Big Tease*, and Spike Lee's *Malcolm X* and *Jungle Fever*. She has also been featured in a recurring role on the television show *Damon* and has appeared in *Just Shoot Me!*, and *Clueless*. Veronica has also taken up fashion writing and television hosting She was recently added as a contributing editor for Conde Nast's Cookie magazine a lifestyle guide redefining modern motherhood..

LANA OGILVIE—the first African American model to sign an exclusive contract with Cover Girl face and skin care products. Lana was selected from thousands of prospects in a models search. This 5'10" Canadian born super model was discovered by an agent while modeling in a high school fashion show. She then went to New York City and walked the runways there and in Europe for top designers Donna Karan and Issey Miyake. Lana has appeared on many covers including Elle and in Liz Claiborne fashion ads.

ALEK WEK—the Sudanese-British model who first appeared on the catwalks at the age of 18 in 1995, sparking a career lasting to date. She is from the Dinka ethnic group in Southern Sudan but in 1991 she and some family members fled to Britain to escape the civil war in Sudan. Wek was discovered at an outdoor market in London in 1995 in Crystal Palace, south London, by a Models scout. She later moved to the United States. Alek first received attention when she appeared in the music video for "GoldenEye" by Tina Turner and from there entered the world of fashion as one of its top models. She was signed to Ford Models in 1996 and was also seen in the "Got 'Til It's Gone" music video by Janet Jackson that year. She was named "Model of the Year" in 1997 by MTV. Wek was the first African model to appear on the cover of *Elle*, also in 1997. She is a missionary for World Vision, an organisation

which combats AIDS, an ambassador for Doctors Without Borders in Sudan, and devotes time to UNICEF. In 2007, Alek Wek released an autobiography, entitled *Alek: From Sudanese Refugee to International Supermodel,* documenting her journey from a childhood of poverty in Sudan to the catwalks of Europe.

KAREN ALEXANDER is an African American fashion model and actress, born in New Jersey. She has appeared in the Sports Illustrated Swimsuit Issue twice and on the January 1989 cover of Vogue. She has also appeared on the cover of Elle, Glamour, Mademoiselle, and Harper's Bazaar. She was included among People Magazine's first list of 50 Most Beautiful People in 1990. She appeared in the 1995 film "Bad Boys" with Will Smith.

CHANEL IMAN is an African American fashion model perhaps best known for her work for Victoria's Secret. The Atlanta born model started modeling with Ford Models at the age of 13 as a child model in Los Angeles, California. She flew to New York in 2006 and won third place in Ford's Supermodel of the World contest. Shortly after, she signed on with the agency. The New York Times wrote a feature article on her, "A Model from Day 1," in which Iman explained that she wanted to be a model her entire life. In May 2007, Iman appeared on the cover of Vogue as one of the world's next top supermodels. In October 2007, Iman appeared with her mother on an episode of the Tyra Banks Show. In both February and July 2008, she appeared on the cover of Teen Vogue, first alongside Karlie Kloss and Ali Michael, photographed by Patrick Demarchelier, then with Jourdan Dunn. She walked the 2009 Victoria's Secret Fashion Show. On September 9, 2009, Iman appeared as a guest judge on the two-hour season premiere of America's Next Top Model. In 2010, she became a featured model on Victoria's Secret's website and was used in several of the company's campaigns. In 2010, Iman became a Victoria's Secret Angel.

Other Top Models Who Made the Limelight:

EVA PIGFORD was the first African-American model on the show to be named the Next Top Model. Her stunning golden skin and spunky appeal was enough to win over the judges. Her prizes included a CoverGirl cosmetics contract, a spread in *Elle*, and a modeling contract with Ford Models. Eva has appeared on the cover of *Brides Noir, Women's Health and Fitness, King magazine, IONA* and *Essence* magazine. Among her other modeling credits she includes: CoverGirl, DKNY, Samsung and Red by Marc Ecko. Eva officially dropped "Pigford" from her name, now going by Eva Marcille, She has recently joined the cast of *The Young and The Restless* as a young mother named Tyra Hamilton After a few months, her character, who was planned to be temporary was made permanent. In 2009, Marcille was nominated for two NAACP Image Award for Outstanding Actress in a Daytime Drama Series for her *Y&R*.

Naima Mora, with her Mohawk and introverted personality, Mora was originally thought to be a long-shot to walk away with the title of *America's Next Top Model*. The judges were swayed by Mora's final performance on the catwalk. Her win consisted of a fashion spread in *Elle*, a contract with Ford Models and a $100,000 contract with CoverGirl cosmetics. Mora has done print modeling for *CoverGirl, ELLE* Magazine, *Fuego* Magazine, *US Weekly* Magazine, *Radaar* Magazine, *IN Touch* Magazine, *Star* Magazine, *Teen People* Magazine, Split Clothing, amd Jazz Album Samsung. Mora's runway shows include Christopher Deane Spring 2006 Collection, Gharani Strok Fall 2005, Carlos Miele Fashion Show, Walmart and ELLEgirl Presents Dare To Be You. Mora is currently singing for the band "Galaxy of Tar." In May 2010, they released a two-song single, "Volatile Glass".

Men in Modeling

Male models have many doors open to them similar to their female counterparts in fashion—on the runway, in catalogues, or in the showroom—or in print or commercial advertising. Because this area has become so lucrative, most of the top agencies have a specific department just for male models. Even though there is substantial work for the teen male, the market is different in that a male model's career usually takes off in his early 20's as opposed to the female's career in her teens; and it can last, in many cases, past his fifties.

For fashion modeling, the male should be between 6' and 6'2" and well-built. The sample size for male models is 40R and there is generally no variation here. The male's sample shoe size is usually 10. In commercial advertising, there is no specific criteria for height and size unless it is for clothing ads.

A male model must possess charisma, a nice personality, great posture, sex appeal and nice facial features, such as straight teeth, good cheekbones and nice eyes. Hair type, color and length, however, do not play a major part in casting as long as it is neatly trimmed and well groomed. In some instances, bald models have even become a big hit! The shaving options vary as well, depending on the client. A male model might work whether he wears a mustache or beard, or if he is clean-shaven. A male model has a variety of opportunities and images—there is no stereotype here.

Europe can be a great place for a male model to get started in fashion editorial and runway. If you meet the physical requirements, a trip abroad is strongly recommended.

For a male model, the more exotic you are, the more you might be sought after. If modeling is the career you are seeking, watch your diet and work out regularly. Once you set your sights on modeling, it's up to you—network, be visible and stay focused!

TYSON BECKFORD grew up in Rochester, New York discovered Bethann Management after seeing her son (Kadeem Hardison) talk about her company on the Arsenio Hall Show. At 24 years old, he beat the odds and become the hottest male model in the world. His story

and claim to fame are not through the usual channels that would be anticipated in becoming a supermodel. Tyson came from the streets and lived hard, but he had a good upbringing and managed to take his success in stride. In 1992, he was recruited to hip hop magazine The Source by a talent scout, Jeff Jones. He went out on go-sees and his life changed drastically in 1993 when he was retained for a Ralph Lauren as the front model for the company's Polo line of male sportswear. He had no prior modeling experience. His strong facial features and buffed body made Tyson a six-figure supermodel with an extraordinary future in fashion.

The first and only male African-American model that has created raving reviews is Tyson Beckford. He is known around the globe for his extraordinary physique, awesome facial structure and crazy tattoos. Tyson is right now the lead model for Ralph Lauren.

Tyson is also known to be the highest-paid and richest male super model of the world. He's also famous for being featured in Britney spears Toxic video. In 1993 Beckford was recruited by Ralph Lauren as the front model for the company's Polo line of male sportswear. His name continued to rise and he was named "Man of the year" in 1995 by VH1, and as one of the 50 most beautiful people in the world by People magazine. He is represented by Nous Model Management in Los Angeles, California, and Independent Models in London, England. He was ranked at #38 on VH1's 40 Hottest Hotties of the '90s. Beckford is co-hosting the modeling contest Make Me a Supermodel on the television channel Bravo with fellow supermodel Niki Taylor.

Now you know who the leading African American models are. To find out more about the models listed, go to the library or your favorite bookstore and do a little research. Learn how your modeling dreams can come true too.

The Ultimate
Fashion Show Experience

There's not much you can count on when it comes to fashion. Trends come and they go. But one thing in the world of fashion people can count on is that the **Ebony Fashion Fair** continues to lead the way in showing Black America the latest in high fashion.

The Ebony Fashion Fair has not only premiered creations by the world's biggest designers, but also made big stars out of some of its models.

It's been more than 50 years since the show was created, and to this day it has remained in a class of its own every step of the way.

Eunice Walker Johnson (April 4, 1916 – January 3, 2010) was the wife of publisher John H. Johnson and an executive at Johnson Publishing Company. She was best-known as the founder and director of the *Ebony* Fashion Fair, which was started in 1956 as a hospital fundraiser and became an annual fashion tour that highlighted fashion for African-American women.

A true fashion pioneer, Mrs. Johnson traveled abroad to purchase creations from the world's best-known fashion houses for more than four decades. During this time, she earned a place in fashion history as the first African American ever to purchase from across the Atlantic for a traveling fashion show. The fashion extravaganza made history and established itself as the world's largest traveling fashion show -the only one of its kind, Black or White.

Under the direction of Ms. Johnson over 4,000 shows were performed in the United States, the Caribbean, London, England, and Kingston, Jamaica. Ebony Fashion Fair raised more than $55 million for various scholarship groups, allowing hundreds of young people the opportunity to further their education.

The show has been noted for its bold outfits that celebrate the human body. It's nothing to see sheer camisoles and blouses that reveal breasts, pants that expose the buttocks or evening gowns with splits so high they become the talk of the fashion show. And while many of the creations appeared "wild" back then and even now, it seems that the show is well ahead of its time. Today thongs have become a necessary fashion statement for women who don't want panty lines to show.

Keeping up with fashion trends isn't the only thing for which the show has been recognized. Throughout the years, patrons are introduced to creations by world-renowned Italian, French, British and Japanese designers. And, throughout the years, African American designers also have been showcased from **Stephen Burrows** to **James Daugherty** to **L'Amour** to **B. Michael** to **Quinton de Alexander**. While fashion is the staple of Ebony Fashion Fair, the show has also launched careers. Some of the Ebony Fashion Fair models have become stars in their own right thanks, to their great start with the show.

Famed actor **Richard Roundtree** and former "First Lady of the Pentagon" **Janet Langhart Cohen** are just a few who got their start as models with the show. Roundtree was a salesman in a haberdashery in 1967 when Mrs. Johnson discovered him in New York. Tall, dark and handsome, the dimple-faced Roundtree was a hit on the runway. He later went on to score big as the smooth detective John Shaft in the Shaft action movies. His cool leather look ended up starting a fashion trend for men in the 1970s. Today, men continue to emulate that style.

Janet Langhart Cohen, a former co-host of the syndicated "Good Day" show, also strutted the runway as an Ebony Fashion Fair model. After college she worked as a model for the show and credits the grace and poise she learned under the tutelage of Mrs. Johnson for her success

in television. **Langhart Cohen** was among the first African American women to break into television. She worked for ABC, NBC and CBS, in addition to BET. The award-winning veteran of journalism and television currently is president and CEO of Langhart Communications. She is the wife of former Defense Secretary **William S. Cohen**.

Pat Cleveland, the youngest ever to tour with Ebony Fashion Fair at age 15, used her experience with the show as a springboard for what would become a successful modeling career. Cleveland, during the '70s, became one of fashion's biggest African American runway models. Before the term supermodel was formally coined, the pioneering beauty was considered among one of fashion's first African American "supermodels." **Terri Springer** was the undisputed "star" of Ebony Fashion Fair from 1959-1964. Today many people still recall the grace and beauty of the regal, mocha-colored model. The daring and beautiful Springer hit the runway like she owned it with explosive drama and elegance. And during a day and age when women with dark skin weren't eager to wear bright colors, Springer wore bright colors as if they were made exclusively for her.

Actress **Judy Pace**, along with the Queen of Soul **Aretha Franklin** , was the first to model in ads for Fashion Fair Cosmetics. After touring with the show, the lovely Pace went on to appear in such films as The Slams, Cool Breeze, Brian's Song and Cotton Comes to Harlem. She also appeared on the '60s TV series "Peyton Place." She is the widow of baseball legend **Curt Flood** . Like Langhart Cohen, **Sue Simmons** found a career in television following her stint as a model. A veteran of more than 25 years in television journalism, today Simmons is a WNBC co-anchor of "News Channel 4/Live At Five," and "News Channel 4 at 11 p.m.," New York's No. 1-rated late newscast. Former Ebony Fashion Fair models **Wendy Wiltz** and **Joslyn Pennywell** went on to join the cast of the hit television reality show, "America's Next Top Model", hosted and produced by supermodel Tyra Banks.

Roundtree wasn't the only male model to go on to do great things. **Eddie E. Hatch** landed a role on the soap opera "All My Children" and later on "Another World." He also did stunt work for **Billy Dee**

Williams and appeared in movies such as Hot Shot, Street Smart, The Warriors and High Stakes. Ebony Fashion Fair model **Hal DeWindt**, a noted teacher and acting coach in New York for more than 20 years, was involved with classic films such as Cotton Comes to Harlem, They Call Me Mr. Tibbs, and Sounder.

As an aspiring model, if you are fortunate enough to be selected to tour with Ebony, you will have gained as much runway experience as you could ever dream of gaining abroad during the same time period. Being selected as an Ebony Fashion Fair Model is one of the highest tributes that can be paid to a young aspiring model. If you meet the qualifications, don't even think twice about it. Go for it!

Contact:

Ebony Fashion Fair
820 South Michigan Ave.
Chicago, IL 60605
www.ebonyfashionfair.com

Tips From Top Fashion Industry Professionals

"I look for well groomed models with current hair styles, manicured nails and a flawless complexions. I prefer to work with models that are between 5'8" and 5'10" with a dress size of 6-8. My models should also portray a sense of elegance and sophistication and have the ability to make clothing come alive on the runway."

–Therez Fleetwood, Fashion Designer, NYC

"I believe that a model should be serious about the business. They must be motivated, have the desire and the willpower to succeed. When an agency criticizes, it doesn't mean stop, it means try harder—it's all about will."

**–John Blassingame, President
Linden New Day Associates Modeling Competition**

"What I look for is classic beauty in all shades from fair to dark, with good skin and clear eyes. A bright spirit and a positive attitude definitely make a difference."

–Adrienne Moore, Editor-in-Chief, Hype Hair

"A model should possess basically something different—out of the ordinary. In particular, a commercial model should be pretty, cute or handsome and be at ease in front of the camera. They should have an easy personality and a natural smile. A model specializing in fashion should be exotic, not too beautiful, but with a distinct or different look having the ability to stand out in a crowd. A female model should have cat-like eyes, be fluid and lanky with a height between 5'9" to 6'".

**–Wayne "ZOOM" Summerlin
International Fashion Photographer**

"Depending on my story, I look for someone who's like a chameleon, someone who can transform into different moods. Real people for real fashions. With black magazines, you don't have to use the standards that white magazines use."

–Ionia Dunn-Lee, Fashion Stylist & Reporter

"I prefer models who possess a certain quality—an inner beauty and specific height requirements. For women–5'9" with a dress size of 4-6; men–6'2" with a suit size 40R-42L. Most important, a model should have healthy skin and hair and a beautiful arrangement of features—full lips, good cheek bones and wide-set eyes."

–Dee Simmons, Former Director, Grace Del Marco Models

Is Modeling for You?

Part II:
Is Modeling For You?

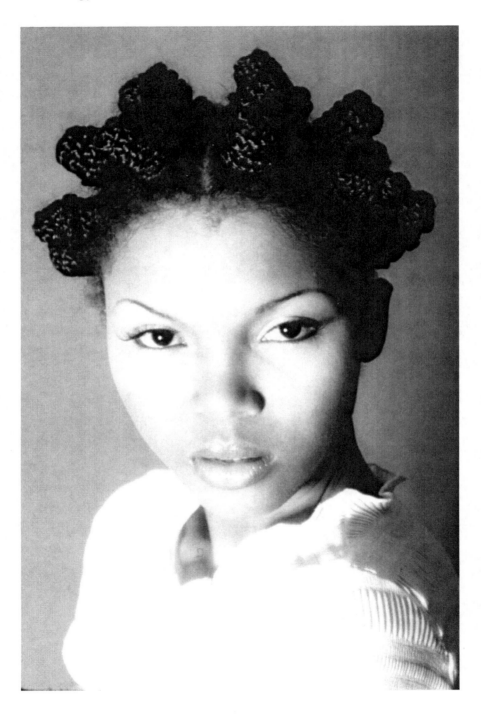

1

So You Want To Model!

Accepting the Challenge of Modeling

Traveling, wearing designer clothes, being photographed by famous photographers, turning heads, having fun, being glamorous and making money—do these things excite you?

Modeling can be a full-time career which requires a lot of hard work. You have to create the "right look" and be prepared to recreate it every new fashion season. Models are sometimes referred to as chameleons because of their versatility and ability to change. Other key essentials for successful models are flawless skin, even white teeth, well groomed hair, a good firm and slender body, the right height and a photogenic face. But, if you're not perfect in all categories, don't worry. As long as you have some of these attributes, you'll get helped along the way by hair stylists, make up artists and other fashion industry professionals hired by the client.

Tyra Banks was asked repeatedly, during her early high school years, "Are you a model?" as you've probably been asked a million times.

So, now if you're determined to accept the challenge to be a model, then let's go forward together. Answer these questions to see if you're ready to take it all the way:

1. Can you be on the set at the crack of dawn, even if you've worked until midnight the day before?

2. Would you work out three hours a day to stay thin and in shape?

3. Are you willing to work at modeling eight hours a day even if you're only booked for two hours?

4. Can you give up a juicy cheeseburger for a tasty tossed salad?

5. Can you put aside your modesty and maintain a comfort level even in a coed dressing area?

6. Are you comfortable being stared at by hundreds of people?

7. Do you handle criticism and rejection well?

8. Can you separate your personal life from your professional (modeling) world?

9. Can you accept a local career as well as being able to handle an international career?

10. Can you tell yourself you're well even if you're sick?

11. Can you work a full time job while pursuing your modeling career?

12. Do you like meeting people?

13. Can you pretend to be comfortable, even if you're miserable?

14. Do you like yourself the way you are and are you willing to enhance those things you may have doubts about?

15. Do you have a unique personality?

16. Are you willing to sacrifice while working your way to the top?

17. Would you consider relocation?

18. Can you squeeze your foot into a smaller shoe size and pretend it's comfortable?

19. Are you willing to work in extreme heat as well as bitter cold weather?

20. Can you undress and dress into an entire outfit in one minute?

21. Would you get a nose job if your agent told you to?

22. Can you put on your make-up while under pressure or in a moving vehicle?

23. Do you like wearing lots of different clothes—even clothes you hate?

24. Are you ready for success?

Now that you've answered positively to most of these questions, I look forward to watching your career as a model develop.

2

Finding An Agency

The trends are constantly changing, so be sure that you know what is in. Just as fashion changes from year to year, a model must also change. He or she must know what look is in, and try to mold a personal image to suit the market. If a model doesn't work for three consecutive months, your agency has an option to drop you. There is an ongoing search for the fresh type of model who will capture the industry and become a million dollar commodity, thus making the modeling industry strongly competitive and ever changing. For just this reason, thousands of new models are granted a chance to enter the market through the top agencies, with the hope of setting a new trend.

There are standard size and height requirements, but if you are a hard driver, and if you happen to possess a special charisma or winning quality, you may be one of the chosen few who are fortunate enough to break the rules and "sneak in". For women, the standard height is usually 5'9" to 5'11", size 4-6. However, the market for petite models (5'4" to 5'6", size 4-6) and for plus-size models (5'8" to 5'10", size 12-14) has opened up recently. For men, the normal height is 6' to 6'2" and the size is 40R or 40L. If you don't fall within these ranges, you must be skilled and polished enough to camouflage the difference. For instance, weight must always be in proportion to height. The emaciated model is not popular today, as the fashion and beauty market is leaning more toward the healthier "all-American look" this year. And of course, healthy clear skin, well-cared for hair, and beautiful hands are of the utmost importance.

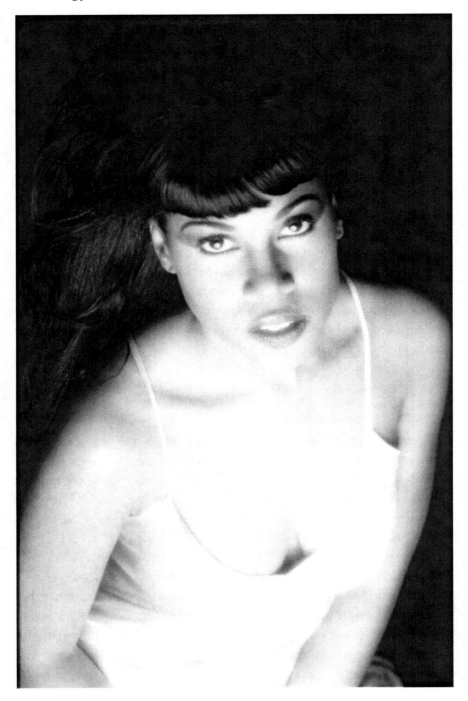

The top agencies are located in the key cities of New York, Los Angeles, Chicago, and Miami. A top agency does not require that you have modeling experience. If they tell you this, the truth is usually that they're probably just not interested in you at this time. Don't be discouraged; keep trying until you are accepted. If you are a new and inexperienced model, however say so . . . and allow them to "discover" you! Top agencies can recognize the difference between new and polished, so if you're not what they want, go elsewhere. Use all comments to your advantage, to change and perfect your presentation. Continue to visit all of the top agencies and any others that might be in your city until you've been accepted at one.

When scouting for an agency contract, take your best picture with you so that they can see how you photograph and advise you. It's not always necessary to make the rounds with a portfolio. Generally, as a novice, you won't have the know-how to compile what the agencies might consider a suitable portfolio anyhow; and most agencies are looking for something different.

If you are accepted, your agency will advise you on the look they want you to have. They'll accept you if they're interested in your type...but only for this reason. Your portfolio will play only a small part in their final decision. On the other hand, if you claim to be an experienced model, be prepared. You and your portfolio must prove it. In other words, don't be halfway. Either you have it, or you don't. You can't fool the experts.

Be cautious about signing contracts; shop around first, and be sure that you are considering a reputable agency. (You should never have to pay to join an agency!) Knowing why you want to model may be the key to your success and to that of the agency. If you're insecure about yourself, you may want to approach a smaller agency first—this could give you the tools and the time you may need to gain confidence. Take your time, if necessary. Remember! Once you have signed with an agency, you won't be able to reconsider until that contract has expired.

If more than one agency wants to sign you, then you are fortunate to have the choice. Ask them as many questions as they ask you.

Prepare Yourself Well...And Go Looking Like A Model!!

3

The Modeling Agency
and How It Works

Models are seen everywhere—on posters and billboards, in magazines and newspapers. When you see them on television, they're usually living like the rich and famous—wearing expensive clothes in elaborate settings. Realistically, modeling is a serious career and profession and should be considered just like any other business that requires education, dedication and determination to succeed.

A model agency seeks work and acts as your bookkeeper, advisor, answering service, secretary and business manager. The agency is usually a key component to your success in the modeling career. They also are the go-between for a model and the client to make sure that the project you are booked for is handled properly and professionally by all parties concerned. They help you to understand and improve upon your appearance, hairstyles, skin care, make up and wardrobe. All things considered, you might compare a modeling agency to a job placement center—they find you work and make sure that the client pays for your services.

The primary focus of the model agency is similar to that of a booking agency—to get the models bookings. Some agencies have people specifically to handle this job and they are called "bookers". There are all types of bookings and the pay rates vary as much as the assignments. For example, a model may be booked to do photoshoots for newspapers, magazines and catalogs, do videos, television commercials or runway

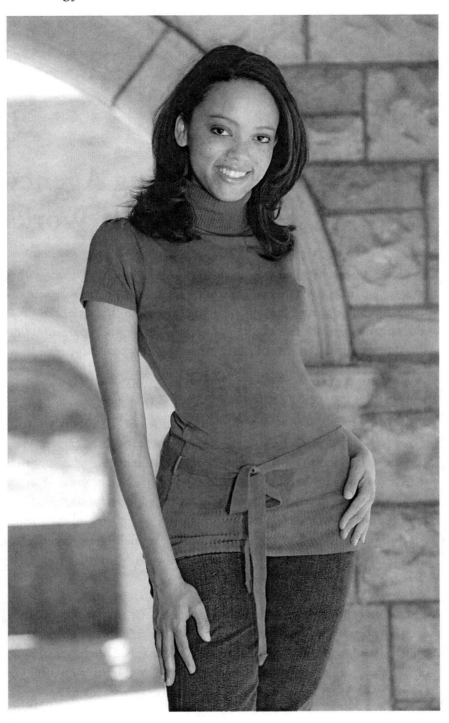

fashion shows. These are but a few types of assignments. The pay range is also very broad. It could be an hourly booking for $150 an hour or a day rate for $2000. Most pay schedules are negotiated by your agent and depend on your experience and the client's budget. Top models can earn millions of dollars a year.

If given a choice, a model should definitely seek out the services of an agency because their contacts are immeasurable. It would take years to establish a list of personal contacts comparable to that of an agency; and when the casting directors are looking for the right model, they will call an agency first.

The majority of agencies offer exclusive contracts to the models that they sign and therefore prevent you from taking assignments from other agents. Even if you get a booking directly from a client that you know personally, you are subject to giving your agent a commission on that job. If you prefer to work freelance

(without a contract) and if your agency agrees to that relationship, you will still be responsible for paying the agency that books you a commission. Sometimes, with this arrangement you may have to end up paying more than one agency fee, because on occasion, two agencies might get the same call from a client and they both might have you on their go-see list.

Once or twice a year, agencies compile a head sheet or book of pictures of their models and use them to promote them to prospective clients, such as: casting directors at advertising companies, video directors and producers, fashion editors, designers, make up artists, hairstylists and photographers. In these head sheets or books, along with the pictures, the models statistics (name, height and measurements) are also listed. You usually sit with your agent to select the one that best represents you. Some agencies might charge the model a minimal fee (about $100) to be represented in their book.

The agent might also include several of the model's composites along with the mailings to their prospects.

Once these headsheets have been distributed, if a client sees a model which they think they can use, they call the agent and request the portfolio and/or they ask to meet the model in person. This meeting is called a "go-see" and it is arranged by the agency with the appropriate time and place agreed upon. The agent then calls the model (it is imperative that the agency has all of your contact numbers) and sets up the appointment. No business should be discussed between the model and client; if the client decides to book the model he or she would call the agent. If the client is looking at more than one model, there might be a call-back needed or a return appointment. After a call-back, a final decision will be made and the model will be put on "hold" until the final arrangements are made. The agent would be provided with information concerning model's wardrobe (if necessary), the time and location, the photographer and of course the pay rate with over-time options would be discussed by the agent and the client. The agent will then give all details to the model who would have the final option to agree on the arrangements. (generally, the agent knows the market rate and can direct you on what's best, so don't be too difficult about accepting your initial bookings—building a reputation can work for or against you.

If you are on hold for an assignment and the assignment cancels or is postponed, you will be entitled to a partial payment from the client (usually 50% within ten days/100% within five days of the booking). This hold has prevented you from confirming other bookings and your agent should always make payment arrangements for you under these circumstances. As a model, it is bad business to cancel a booking—this could prevent you from receiving future assignments. If you don't want to accept a particular assignment, such as swimwear or lingerie, tell your agent in advance and don't go on these particular "go-sees" or represent yourself this way in your pictures. "Tentative" bookings are the only bookings that can be canceled—once you have agreed to be placed on hold, it's too late to cancel respectfully.

An agency will be your protection with regards to receiving overtime pay and in most cases, payment for fittings. When there is a need to travel, you will also be allocated an appropriate payment for travel and preparation time and of course all expenses and a per diem are handled by the client as well. The model's ranges are very widely diversified. With

a new model, payment scales can range from $20 an hour to two thousand dollars a day; some top models earn as much as a million dollars per assignment. Print editorials appearing in newspapers and magazines pay the least amount of money. These are photos that you may pose for in support of a "lifestyle" story or documentation. A reasonable assessment of pay ranges for various types of modeling assignments might go something like this—showroom modeling, fit modeling, trade shows, editorial, fashion shows, videos, catalog modeling, product print advertising and commercial advertising. Once your agency sees the demand for you in a specific category, it becomes easier to promote you and escalate your career as a top model.

For developing your career as a model, overseeing your bookings and getting you paid your rate, the agency requires a service fee which is deducted from your payment on every job you do. Even if the booking does not come through the agency, but is acquired through your personal contacts, it is a good idea to turn it over to the agency for collection—this will give you a better assurance of getting paid in full and in a timely fashion and it will maintain a professional rapport between you and your agency. Most agents charge the models 15 or 20%, but in some cases, if there is a specific agreement for a special assignment, the fee could go higher. The percentage paid for bookings is the only payment that an agency gets for its service to you. So, it works both ways. When a model doesn't work, neither the agency nor the model get paid— if this is the case, perhaps this is not the appropriate agency for you and you should search for one which can market you better.

Most successful agencies have a wide variety of model types—this gives their potential clients more options to choose from. This could include a range of models such as sophisticated "high fashion" types and "junior missy" types. There is also a growing demand for petites and plus-sizes as well. On the other hand, many agencies will not accept two models with the same "look" or features, so be prepared to seek out an agency that may not already have a model with your particular look.

When searching for a modeling agency in your area, you should first look in the yellow pages. If you don't have any local agencies, you might

look up modeling schools. They could refer you to the nearest city that has an agency. (Note the references listed in this handbook as well.) Another way to locate a local agency is by looking in the classifieds or other publications distributed in your area such as "Pennysaver". Note that agencies that advertise this way may be a good way for you to get started, but use precaution in signing long term contracts with them or paying a "sign up fee". Generally, they may not have the types of jobs that could gain you national recognition, but are limited to low-pay bookings. If you are under eighteen, you should always go on agency interviews with a parent. Take all available pictures with you in a pre-sentation book or portfolio. These should be professional photos (8 x 10 black and white) and not snapshots. However, if it is not economically feasible to have this type of photo, try a snapshot or two but be sure to keep the background simple and the focus only on you.

Most agencies that are interested in a particular model will suggest a few reputable photographers to you, but it is up to you to pay for the photo session. In some instances, however, it is possible to have a "top" agencies pay for your pictures and deduct the expense from your first commission check. (This is rare and should not be expected; but when it does happen, you can bet that you are with the right agency and that your potential as a top model is enormous). Avoid agencies that require you to pay them a "fee" to set up your photosession ...photography should not be a "side-business" for a reputable or successful agency. Their area of concentration is solely on the booking or assignments that they can get for their models.

An agency will serve and protect you, but don't depend wholly on their efforts for your success. Ask your agent if they have prospect lists and make the rounds periodically by scheduling yourself with appointments to see those prospects. This can give your modeling business a boost by keeping you more visible. It is often a policy of most agencies to keep a minimal number of ethnic models on their rosters because there is not as much work for them. So, you may need to stay abreast of the trends of market demands, and make sure that your agency is properly promoting you to their clients. If you find that after a certain period of time, you are not working, look around for an agency that attracts

more bookings for ethnic models. For this reason, when starting out, it might be advantageous to join an agency that specializes in your ethnic group. There are several top black models who have built successful modeling careers at agencies that do not specialize, but they represent a small group of actual "working" models. Thousands of models who are represented by smaller agencies that specialize in black models earn very good salaries. This is primarily because their clients recognize the diversification of the models that they represent. These leading specialty agencies are listed in this workbook.

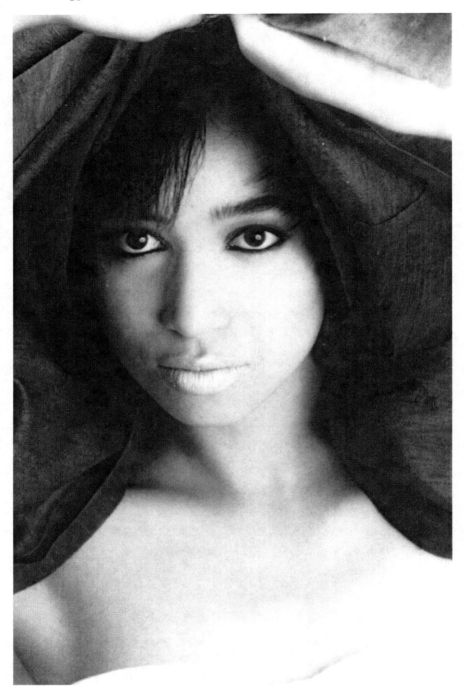

4

How to Be Successful in the Modeling Industry

If you want to make the most of your modeling career, be prepared to discipline yourself and follow these fifteen simple rules:

1. Stay positive! There's a lot of rejection and discouragement in the modeling business, but you shouldn't take it personally. Every job is different and is not necessarily for your type, so if you don't get selected for a particular assignment, stay positive and pleasant–the next job may be yours. Always leave a good impression.

2. Always be on time for your auditions, casting calls, go-sees and, most definitely, bookings. If you have a distance to travel, schedule time for delays. If you definitely are going to be late or can't keep your appointment because of an emergency, call your agency immediately so that they can contact the client to make other arrangements for you or send another model.

3. Make a habit of checking in with your agency on a daily basis to see if there are any casting calls. Check with your agent to see what times are appropriate to call in. If you can't get to a phone on a given day, be sure that your agency has a number or service line where they can leave you a message. Never leave town without "booking out" or telling your agent. If possible, leave an out of town number in case something important comes up.

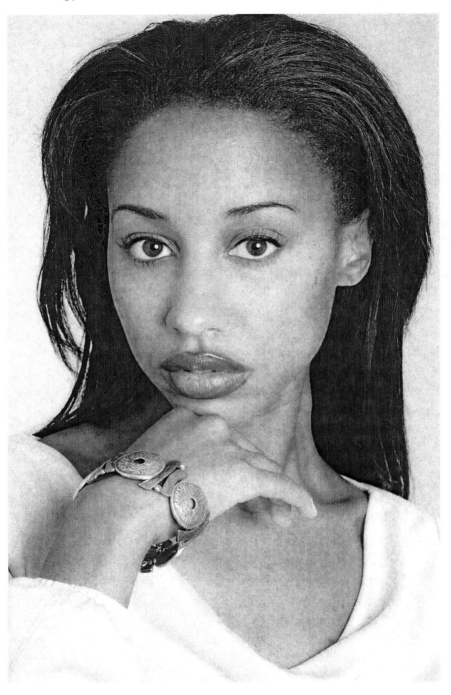

4. Never try to bargain, plead or negotiate with the prospective client. Concentrate on your audition and your personal presentation. The agency will handle the business in your best interest.

5. Be sure to get a clear understanding from your agency of what the client is casting for. Dress appropriately for the particular look that they want and if you can't wear the clothes in because of inclement weather or prior appointments, carry the clothing items with you and allow enough time to change in the rest room before you meet with the client.

6. Lend a hand to fellow models in your agency whenever possible. For example, the appropriate shoes or costume jewelry are not always available for an upcoming runway presentation. Helping out another model builds goodwill—and besides, you never know when you'll need a similar favor.

7. Build a trust factor with your agent. Listen, ask questions and share your experiences. If you're not sure about something, ask and if you can't get the answers right away, be patient, wait or drop your agent a note.

8. Always carry composites and your portfolio with you during business hours, whether you have an appointment or not. You never know when an opportunity for an appointment may occur and you want to have your tools accessible.

9. Your portfolio and composites are business tools and should not be shown to everyone you meet—only prospective clients or photographers. Sharing with other models in your agency is okay, too.

10. Check in with your agency on a regular basis to make sure that they have a supply of composites on hand at the office and be sure to get your photos on the agency headsheet as soon as possible.

11. Never discuss the agency's policies and procedures with prospective clients, friends or models from other agencies. If they want more information, have them call the agency directly. This way nothing can be misinterpreted.

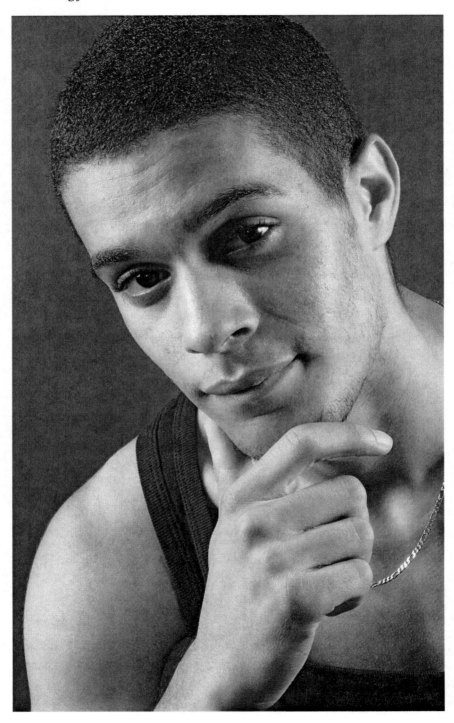

12. Be respectful of yourself and other models in your agency. Your reputation is important to the well-being of yourself as a model and your associates. Flirting and gossiping can be detrimental to the building of your career as a model.

13. Keep track of your time when you are on assignment—arrival and departure. Never show up late or work overtime without calling your agent with the details. Your payment voucher should be completely filled out and signed at the completion of your assignment and handed in or mailed the same day or the following day. This is the only way to assure proper billing and payment.

14. Never sign a model's release for photography or videos or any other reason without specific prior instructions from your agency. If the client insists, have them call your agent immediately, but don't allow them to persuade you. Sometimes when you do test photos, you are asked to sign a general release. If you are not yet with an agency, be sure to have someone with your interest in mind read over the release thoroughly.

15. Do not, under any conditions, give out your phone number to someone who claims to have an interest in you as a model. When you start making the "rounds" or pursuing your career as a model, you should have an agency's number or an answering service.

5

Getting To Know You

First of all, I'd like to introduce you to yourself. Stand in front of a full length mirror, and examine every inch of your body from head to toe. Are you satisfied? Or is there room for improvement? Are you the best you can be?

Begin with your hair. Is it suitable for your facial frame? Does it harmonize with your lifestyle? Is it all together or do you need professional help? Hair salons can offer you that help and they're easy to find. If your hair is limp and oily, broken and uneven, dry and brittle, too straight or too curly, make sure that you seek out a professional stylist who can give you a personal consultation regarding your hair.

Now, look at your eyes. Are they bloodshot or clear? Do you squint a lot? Maybe a check-up with an optometrist wouldn't hurt! Whether you are experiencing a problem or not, remember that annual eye exams should be part of your good health regimen.

What about your teeth? Are they even or crooked? White or yellow? Are any missing? Remember, your mouth is important! A check-up twice a year and tooth cleaning with your dentist can help.

Is your skin healthy, clean and clear? Or are you looking at a multitude of blemishes? There are many skin care products on the market developed to address specific skin problems; and of course, proper vitamins, eating habits and diet can control many skin deficiencies. However, if

you are taking proper care and eating well and still experiencing problems, see a dermatologist.

Your clothes can hide a multitude of flaws. Therefore, remove them and face the bare facts. How's your body? Is it in good shape or is it in need of a tune-up? Is your stomach firm or flabby? Do your thighs rub together when you walk? Do your hips spread too much? Do they hang over the edge of a chair when you sit down? Take control of your body. Be aware of its appearance. There are many team sports and activities in high school and college, or if this does not apply, find the nearest gym, spa or local "Y". Remember, your best personal trainer is yourself. Obtain and maintain your body's fitness and tone by using an exercise program that's good for you.

Now, check out your feet. Have you been treating them well? Or are you mistreating them by wearing improper shoes? Do you treat yourself to an occasional pedicure? Remember, the condition of your feet can affect your overall posture, and the way you walk or carry yourself as a model is very important. Walk around a little bit. What kind of stride do you have? Is it choppy or smooth? Is it confident? Do you like what you see, or is there room for improvement?

Now that you've dealt with the bare facts, get dressed again. Are your clothes flattering to you? Do they show off your best assets? Are they comfortable, or do they restrain you? Knowing how to shop for yourself is very important. If you have difficulties, seek out a specialist or a fashion consultant who can give you the proper insight and the know-how to make the best selections for your body shape and age.

Always remember! A person's first impression is a lasting one! Every facet of you must combine to make that impression the best it can be, to give you the very best for yourself. Your self-development is very important. You're very important!

6

Be Prepared

In order to be consistent and successful as a model, you must treat modeling as a business. You must keep on hand, all of the necessary tools: your portfolio, composites, resumes, cosmetics, an updated wardrobe and accessories, a watch and an appointment book. Most of your tools can be carried in a "tote bag". In fact, if you keep it packed with the necessities for a show or booking, you'll always be prepared to work, even on short notice.

There are not too many stories told where a model becomes an overnight success; therefore it would be wise to seek alternate goals and continue your education. Sometimes a part time or temporary job is necessary when you are first starting out in order to pay your living expenses (if you're not living with your parents) and to keep you supplied with your business tools. However, if modeling is your true aspiration, don't get locked into a job that doesn't give you the flexibility to take a few hours off on short notice.

An inexperienced model should participate in and attend as many local fashion shows as possible for the experience, so that when you go to an agency for an interview, you are more confident and knowledgeable. Prepare a resume, even if you have not worked professionally yetinclude all modeling, acting, singing, dancing, and educational experience; as well as your measurements, age range (a ten year span if possible), and your hobbies and special skills such as bike riding, roller skating and swimming, etc.

7

What's Your Market?

Are you a candidate for Runway, Print or Commercial Modeling? Possibly it's Showroom, Fittings or Trade Shows? Do you have lovely hands, beautiful hair, a flawless complexion, shapely legs or the perfect shoe size? If so, your field is perhaps Specialty Modeling.

First of all, you must know yourself; you must have an abundance of patience; and you must get along well with other people! You must have a positive attitude, know your likes and dislikes, your strengths and weaknesses. Assess your personality and set your goals! Now you're ready to determine your market!!

In order to qualify as a RUNWAY model (unless you specialize in petite or plus sizes), you should preferably be between 5'9" and

5'11", and wear a sample size 4 or 6. You must also move well, know how to follow instructions, and be a lover of fashion. There are a few exceptions to this rule, but only if you are exceptional! For runway modeling, the pay is anywhere from $200 to over $2000 a day for the average model, depending on the designer and the type of show or production.

PRINT models are used for advertising fashions, products, or story ideas (such as editorials which pay the least, but are great exposure for a model just starting out). Print modeling is not usually as restrictive (with the exception of fashion), because as long as you can sell a concept through your personality and your image, your height does not play

a key part. You must, however, be pleasing to the eye, have a friendly smile, unique characteristics, a good attitude, lots of patience, and be able to follow instructions well.

Remember, time is money! So don't waste it. You may earn an average of $150 to $500 an hour, or a day rate of $1,000 to $3,000.

(Some "top" models earn $10,000 or more per day). In addition, if you've modeled for a specific product line, you may be entitled to a "usage" fee. This is usually paid if your ad runs longer than the initial contracted period, provided your agent made arrangements in your model's contract with the client.

As a COMMERCIAL or CHARACTER model, you must have some acting ability. Reading and speaking well are essential. You must also have good salesmanship and good eye-contact. When filming, the lens is your audience—learn how to react to it and love it. For television commercial work, your weight and proportions are important, because the camera may add as much as ten pounds to your actual weight. Generally, the base pay is similar to print, but for commercials, you often receive residuals whenever they are aired.

A SHOWROOM model must be well-poised, have a pleasant personality, be a good salesperson, and be able to wear sample sizes well. The dress size is generally 4 or 6; the height requirements usually range from 5'7" to 5'9". Many showrooms are located in New York City on famous Fashion Avenue (7th Avenue). This type of modeling can be a very reliable source of income once you get established with a particular design house. The busiest times are during "market week" for preview showings of spring, summer, fall and winter lines. However, if you prefer to do showroom modeling full time, you will often be asked to work eight hours a day/five days a week—there is less flexibility with this type of modeling because you must be available whenever a buyer comes in. If you have to leave or take a day off, be sure that you or your agent have arranged for a replacement model.

FIT models must have excellent proportions, because they are used for sample fittings. They are basically human mannequins who are seen only by the manufacturer, pattern maker and designer. Clothes are pinned, tucked, altered, and refitted—there is a lot of patience involved here. The pay can be steady, however, ranging from about $60 to $150 an hour.

A TRADE SHOW model works at conventions such as the

"Auto Show", "Home Show", "Boat Show" or "Beauty Products Show" during which you represent a specific company by demonstrating products, passing out samples or brochures and greeting customers. Working at a booth, you're usually on your feet about 8 to 10 hours a day, but it does pay the bills. The usual rate of pay for Trade Shows is about $100 to $300 a day. The requirements are more variable in that there are no specific measurements or height requirements—just the ability to project well through a pleasant personality and to present a neat and attractive appearance.

SPECIALTY modeling includes several options: If you have especially good HANDS with long slender fingers, no wrinkles or scars and well-shaped nails, you might wish to direct your efforts toward hand modeling for print or television or product demonstration. Hand models can earn anywhere from $15 an hour for product demonstration or up to $250 an hour for advertising. Your HAIR must be lustrous, thick and healthy (usually shoulder length or longer) in order to model for a hair products company. Hair shows and hairstyle magazines are also good ways to get noticed when you are starting out, but stay away from "testing" new products. BEAUTY PRODUCT or FACE models must have a blemish-free, even-toned complexion, good teeth, and a good bone structure. Some hair and beauty models work out long-term contracts with top corporations and do repeat business or endorsements which may pay as much as six figures depending on the terms. If your LEGS are long and shapely, you may be eligible to model hosiery and depilatories, and depending on your other body proportions, swimwear and lingerie. For leg modeling, you usually have to be at least 5'8" and have no visible veins or scars.

A SHOE model should have a perfect size 6B foot, and of course, a well-proportioned leg. Your feet should definitely be neat and well pedicured and in no case should you have corns, callouses or bunions. Shoe modeling can be for fit, print or runway and can pay as much as $150 to $500 a day. If you get steady work with a reputable manufacturer, you may be asked to travel with him or her—a perfect shoe fit is hard to find.

Other markets which have opened up recently and for which there is a growing demand for models that may be considered Specialty are PLUS or LARGE SIZES and PETITE Models. Plus Sizes generally weigh 140 to 200 pounds, wear size 12 to 18 and measure in height between 5'7" and 5'10". Petite models are generally 5'2" to 5'4" and wear sizes 4 to 6.

Now That You Know Your Market.....
Target Your Efforts In The Right Direction!!!!

8

That First Impression

Make that first impression a good one, because it's the most lasting. Have you ever thought to yourself "Seeing is believing", or on the other hand, "You shouldn't judge a book by its cover"?

Regardless of what you've thought, or how you've interpreted someone's appearance, that first glance left some sort of impression on your mind.

The characteristics that label a person either friend or foe, rich or poor, happy or sad, success or failure, are generally assumed unconsciously through the eye of the beholder. Naturally, the assumption is established by one's speech, carriage, dress or style, and grooming habits. All of these characteristics can be observed in one quick glance. Therefore, if you are in a position that requires public contact, you must understand the advantages of a positive personal image.

Let's begin with your SPEECH. It should be clear, crisp, concise, confident and expressive. Avoid shrilly, whiney, nasal tones or loud, boisterous, harsh sounds. A good way to improve your speech is to read a lot and to practice speaking into a tape recorder. An idea to improve your voice is to watch yourself in a mirror, while talking and to smile a lot…this makes for a more pleasant and exciting conversation. If your speech is poor, because of inadequate training, seek out a course in English composition. And remember, when you do converse with someone, look them in the eye, not up at the ceiling or down at the floor.

Another very important characteristic is your CARRIAGE, otherwise referred to as your posture, stance, visual poise or body language. This particular characteristic can tell a lot about your attitude and confidence level and if it does not reflect a positive image, then it is essential that you work to improve it. Having good posture can make you appear taller and slimmer and give you the illusion of moving more gracefully, thereby making your clothes look better. Good posture is a definite asset for a successful model.

DRESS or STYLE refers to the way you present yourself to the public. Always be careful to portray yourself in the manner in which you would like others to see you. For example, If you want to appear youthful and wholesome, avoid clothes that are tight fitting and feature low-necklines. Day-time dressing should not be confused or combined with after five attire. When you are going out for an audition, pay particular attention to the job that they are casting for, and go looking the part. Listen to flattery and take notes regarding specific colors or clothing styles, and wear those items when you need to make a great impression.

If your GROOMING and HYGIENE habits are lacking in discipline, none of the above will benefit you. The discipline of cleanliness and personal care can be considered the fundamental of your success as a model or in any other profession that you embark upon. Always maintain a clean body, hair and teeth; remove excessive facial, underarm and body hair; use appropriate skin care products and deodorants daily; keep your hands manicured and your feet pedicured; and pay special attention to the condition of your wardrobe. Perfect this area of your personal image and your chances for success as a model will be greatly increased.

9

Wardrobe Builders—
Form Good Shopping Habits

Now that you know what it takes to be a model, here are some tips on making the most of your available budget.

When selecting your fashions, begin with a color story. Test different colors next to your skin to see which one works best with your complexion. Work with a family of colors that compliment each other, as well as your skin tone. After you determine whether to choose vibrant colors, deep hues, or pale shades, begin your selection of styles. Creating an image comes from developing your own personal style. First, begin with comfort. Then consider your physical attributes. Do you look better in loose, bloused clothing; or do fitted fashions work better? Do you need to be conservative and tailored, or can you be free spirited and trendy? Remember, you should never feel self-conscious in your clothing.

Of course, your profession should help to set the course for your clothing choices. As a model, you should consider the many wardrobe options necessary to look the part that might be open to you. Check your priorities. Do you need clothes that suggest school or work? Sports or partying? For instance, you might be called upon to look like a student, an athlete, a career professional or an entertainer. You may need a clothing range that will be adaptable to all of these looks as well as those that fit your personality on a day to day basis. Buy clothes that mix with the fashions that you already have and consider how often you

can wear them. The well-fitted basic black dress is the all-time winner for versatility. A suit is a great buy because you can mix or match both skirt and jacket, and either can be dressed up or down. Note the value of a good wardrobe and find out how your fashion selections affect your status as a successful model.

Consider the clothing's quality too. Quality clothing lasts a lifetime! Buy fashions that will give you more mileage, such as classic styles in basic colors and natural fabrics. Keep in mind that status is associated with fine quality, as well, and always strive to look your best. If the clothing you choose is well-made out of fine natural fabrics such as silk, cotton, linen or wool or quality blends (mixed with naturals), you've probably made a wise choice. Natural fabrics such as cotton, linen, wool and silk are more durable and more versatile. Some of these natural fabrics (depending on the type or processing) may shrink slightly when washed or dry cleaned. On the other hand, some natural fabrics (particularly knits) may stretch. In order to get the best fit and appearance, find out what tendencies may be expected from the garments that you choose, and adjust the size accordingly.

Underneath it all, consider the proper foundation—your undergarments will affect the overall appearance of your wardrobe. Be sure to select the appropriate items to fully enhance your figure. For this, the proper fit is essential—they must be neither too tight nor too loose. If you're not sure of the proper type or size for your figure, confer with a consultant in a lingerie store. Generally, a model should stick to nude and black undergarments—panties, bras, slips —with no lace, trims or bows that might show through the clothing. Smooth lines are mandatory—in some instances, you may need to wear only pantyhose to create the necessary illusion (thus, the importance of a firm, trim body).

To keep the illusion smooth, firm and trim, body-shaping lingerie is a must. Some companies make half-slips with elasticized fabrics that control and contour as well as full-slips that come complete with a firming underwire body-suit. There are also many styles of panties or girdles available which will cinch your waist and tighten your buttocks and thighs. Shop around for these all-important items to help keep everything under control. A good variety of bras for a model would

definitely include sweater bras for a smooth look or strapless bras for those low-cut or off the shoulder styles. To get the appearance of more cleavage push-up bras are perfect. If you need a fuller bosom, there is now a safe alternative to surgical implants called "breast enhancers" for under $150, which are natural looking and comfortable to wear. A bodysuit or body stocking can be a model's best friend, particularly when it comes to fittings and when you're doing particular assignments which include quick changes. Other undergarments which a model should consider are shoulder pads and underarm shields. Following these guidelines will give you the confidence you need and the necessary tools for building your basic look.

When you shop for new clothing, always be truthful with yourself about its practicality and its fit. After all, unless you are buying it for someone else, you should try it on in front of a full-length mirror, and take an honest evaluation—or bring someone else along who will. Looking good should be the primary consideration that you have when you select your clothing. Be totally aware of your proportions. Does it fit well? Is it comfortable? Does it flatter you? Is the color right? Is it practical? Assess yourself. What is your height, weight, skintone, and your market? Determine what type of skirt looks best on you? What length skirt looks best on you? What style of slacks? What style jacket or coat? Know your own wardrobe needs.

Avoid impulsive shopping. Before you shop, organize your closet so that you will know exactly what you need. Separate your clothes by the seasons in which you wear them. This will make it easier for you to identify which clothes to use for specific modeling assignments. Fabrics and styles should determine the proper placement of your clothes. Then separate everything by category, such as blouses, sweaters, skirts, slacks and jackets. Arrange your clothes according to color, and make a list of what you have. Now updating your wardrobe should be easier. Take your list with you as a guide and buy the separates that will be functional for you as a model. If you're shopping for a special occasion, sometimes you may be too impulsive, so don't wait—know in advance what will complement your existing wardrobe and fit in those pieces when you

find a great bargain. An outfit is almost useless if you can wear it only once—make sure you love what you buy.

Plan your wardrobe around your budget and your needs. Your clothes are an investment and should be able to hold up to a lot of wear. It's always better to buy something that is a little more expensive and well-designed than to purchase something cheap that may fall apart after a few days of wear. The more you can wear it, the less it will cost in the long run. Classics and basics are items which last for years. For instance, build your wardrobe around a main collection of clothing items, such as blazers, slacks and shirts in black, brown or navy. They never go out of style and can be updated instantly with trendy accessories. After you build your foundation with these basics, you can then add other colors, prints, textures, tones, accessories, and even an occasional "fad".

Don't get in the habit of always buying impulsively. Plan ahead and be practical. If you plan ahead, you'll get more for your money. Buy only what you need to expand or complement your current wardrobe. There are many ways to look fabulous without paying the full price for expensive designer clothes. Check stores which have sales on items you need, and compare the quality of the items before you buy them. Some major fashion houses, particularly in cities like New York and Los Angeles, have showroom sales where you can buy designer samples right off the rack. Every now and then, it's fun to visit your neighborhood thrift store for bargains—if you do, prepare to spend lots of time rummaging through the many racks of coats, suits, blouses, skirts and dresses.

There are other shopping alternatives to consider which will offer you affordable great-looking, well-made garments such as outlets, discount stores and flea markets where you, more than likely, will find some great quality buys! Consignment shops or resale shops take in top designer clothes and shoes from wealthy clients and sell them to the public for a fraction of their original cost. Unless you are the type of person who can afford a different dress or outfit every single day of

the year, then you should strongly consider the advantages of careful planning and smart shopping.

Before you make that purchase, check your clothing for workmanship, and maintain your wardrobe carefully to present a fresh appearance. Make sure seams and hems do not pull apart or unravel. Buttons should be secure at all times, and zippers should be tightly stitched and flat. Make sure that after you wear an item, you hang it or fold it properly. For instance, slacks should be folded seam to seam, and hung on a special pants hanger with padding or clips. Skirts should always be hung with clips. Blouses, especially silk ones, should be hung and buttoned on a padded hanger. To avoid stretching, sweaters should always be folded. Never put away clothes that are soiled or stained. Clean them immediately, iron them and store them. If you can't visit the dry cleaner regularly, then avoid purchasing clothes that require this service. Be sure to review the care label before buying. Hand washing and machine washing are most economical, but you can ruin clothes that don't specify this type of care—you should also note whether or not the garment is colorfast before you attempt to wash it. Most better quality garments must be dry cleaned. The care label is there for a reason so be sure to read it carefully.

As a successful model you may become a world-traveler. If so, your wardrobe should be able to withstand many packing and climactic changes. Silk, for example, makes a very satisfactory traveling companion—it's crushable and steams easily in the shower, and takes up less space in your suitcase than most other fabrics. It is both resilient and elastic; and it's lightweight, making it ideal for warm weather. Yet, because it warms to your body temperature, silk also keeps you comfortable in cooler weather. Because of changes in climate, temperatures in and out of offices, drapeability and durability, some fabrics feel better on certain people than on others. Test fabrics in your daily routine and see what works best in your lifestyle as a model.

As you approach new levels in your modeling career, you should also be improving your lifestyle. Therefore, it's not always within your means to buy the very best quality, but rather, the very best

that is within your budget. If you plan your wardrobe well and organize your daily dressing habits, you'll be sure to create a model's image. Keep in mind that being well-dressed is one of the primary considerations that leads you toward a more successful modeling career. Form good shopping habits now, and you'll always have a polished appearance.

10

Accessories–How Little Things Pull Your Outfits Together!

Do you know how to turn two or three separates into a dozen looks? It's easier than you think. I call it "Accessory Power"! With a mere switch of accessories, you can take the most basic wardrobe and turn it into something simple elegant. What fits this category? Belts, bags, jewelry, shoes, hats, scarves and gloves are all important for sprucing up your wardrobe. Any of the above can turn a basic look into an evening style or make daytime casuals into eyecatching ensembles.

Looking good is a cinch if you wrap your waist in leather, from slim to extra wide. Try bright, eye-catching colors, shimmering metallics, or basic tones that are hooked up with big and bold chunks of metal. The key to better belts is the fabric. Avoid inexpensive plastic. Some fabrics are okay, but it's better to have a few quality leather belts than to have several that aren't complimentary to your model's image.

It's not unusual to coordinate your handbags with your belts. If you do, it's safe to assume that the colors will always work with the clothing that you choose. Or better yet, match up your shoes with a soft roomy pouch or backpack slipped casually over your shoulder or tucked securely under your arm. If your day-to-day modeling assignments require an excessive amount of toting, then be sure to get a bag that will work for you while maintaining a neat appearance. Avoid an unsightly

bag that bulges out of shape. And, never carry an evening pouch for daytime activities—it will stand out like a sore thumb. There are some fabulous totes on the market; find the one that fits your modeling career best. If you can't afford leather, choose a bag that's well-designed and easy to coordinate with other items in your wardrobe. Remember, the best bags to tote are neat and chic.

Jewelry will always add excitement to your fashion presentation and is often a necessary part to your modeling assignment. The possibilities for earrings, rings, necklaces, bracelets and watches are endless. For instance, buy a good strand of pearls (in two lengths if possible), and they'll last a lifetime, while giving you the sophistication and class that enhances you throughout the day. In fact, pearls are probably the most practical jewelry that any young woman should own. For sprucing up on those very special occasions, rhinestones, crystal and glass beads always make a hit—stick to those that look like the real thing. Fashion costume jewelry can be very complimentary to your wardrobe and to your model's image. Gold, silver, and brass are designed to make a personal statement, so choose carefully the styles that are most expressive with the modeling market that you have identified with and wish to exemplify. For a wide variety of treasured trinkets, be universal with your selections; or you may even wish to be identified with accessories from a specific origin, such as Africa or India. Jewelry offers you a great opportunity for self expression.

Note: Pierced earrings are a matter of choice. Be cautious in selecting your styles and avoid earrings that may be too heavy. Always remove your pierced earrings when you shampoo, undress, before going to bed, during sports or other strenuous activities and if you are playing with small children. Tearing an earlobe can be detrimental to your modeling career—it can be repaired by a plastic surgeon, but that takes time and money. If your family has a tendency to keloid, by all means avoid piercing. With the quick changes required in runway modeling, clip on earrings are the best choice when you work, whether or not you choose to pierce your ears.

What's more important to your appearance than a great pair of shoes? Nothing! They affect your posture, your style, your stride, and your overall personal image. They must at all times be well cared for and polished. When modeling, your basic black and beige pumps are always necessary for runway and showroom work. Your basic shoes should be your biggest investment. Buy colors that work throughout the week in styles that suit your daily activities. The newest trends in sneakers are always sporty and great for athletic assignments—be sure to have a pair of white tennis shoes for specific modeling assignments, too. When it comes to chic, slip into a pair of soft, leather flats, strappy slides or mesh pumps to complement those more feminine fashions; and for those more casual days, there's nothing better than a boot to express your personal tastes and to add comfort to your stride—try a light tone and a dark tone leather . Don't forget those evening pumps in colorful fabrics or metallic-toned leathers for a quick and tantalizing transformation. Sizing up your footwear is one great way to assure that your image is intact.

Hats are always hot if you wish to add an extra touch or a special flair to your current fashion presentation. The style should be determined by your facial shape, your height, and your haircut. And the fabric should be determined by season. Straws are for spring/summer. Velvets, felts or leathers are for fall/winter. Satin and rhinestone will suit all seasons. Brims look good on everyone, but take a friend along when you determine the size of the brim. (For instance, very large brims are best left to the taller populace; and very small brims are best for the slim frames). If you are uncertain, a medium brim is usually safest. Don't forget about berets and sporty caps—the choices are endless. The color and style that you choose can work with you to project an attitude of confidence, playfulness, romance, or sophistication..So, what's your modeling market today?

Scarves are always fun. A model should own several shapes, fabrics and colors—long oblongs, large squares and bandannas in solids and prints. The best styles are made of silk, but rayon and cotton work well for sportier looks. Whatever outfit you wish to accessorize, scarves will add zest—wrapped on your head, twisted around your waist, sashed at your hips, or tied along your neckline. They're colorful and bright and

come in all sizes and shapes. Plain or printed, scarves can add drama to your dullest fashions. If you haven't tried a scarf or two, you're missing out on glamour.

For warming your fingertips or for feminine flair, gloves are always in fashion and paint a perfect picture of style. Fabric and color choices are available in an endless array. One rule of thumb to remember is to choose softer, more delicate gloves to complement your evening or elegant looks. If worn properly, gloves could be the accessory that gives you a certain mystique, sets you apart from others in a crowd and completes your model's personality.

Other items that can work for you in your modeling career are: headbands, ribbons, barrettes, combs, sweatbands, sunglasses, eyeglasses, sun visors, fabric flowers, and neckties. Being creative is the fun part of making your model's image complete. So, now that you've been introduced to the endless possibilities of accessorizing your wardrobe, become a trendsetter. Make your accessories work for you and s-t-r-e-t-c-h your wardrobe.

11

Put Your Best Face Forward

As a model, you will always be in the spotlight and must always "Put Your Best Face Forward". This means having a flawless complexion, naturally, and keeping it that way; or if you have complexion problems, seeking out the services of a skin specialist. After examining your skin, note which category you might fall into and get help from the appropriate professional who can make the corrections or prescribe the necessary treatment that will lead to a flawless model's complexion.

For example: A Dermatologist is medically trained to treat skin disorders which may include acne, eczema and any other type of eruption or break-out which may cause discomfort, discoloration or scarring. A Cosmetic surgeon will remove unsightly scars or unwanted moles or re-sculpture your facial features such as the nose or cheekbones (plastic surgery). An Esthetician is a skin specialist, licensed to give you facials, waxing, and chemical peels. These types of treatments are neither medical nor surgical, but are recommended at least once a month to all models who wish to maintain a flawless complexion and a healthy glow. (Some estheticians also treat acne and razor bump problems using products that induce a chemical peel). A Cosmetologist usually specializes in hair treatments, but is also proficient in hair removal by waxing or tweezing and bleaching to lighten facial hairs. They are also frequently employed as make-up artists. An Electrologist is licensed to remove unwanted hair permanently by means of an electric current applied to the specific part of the body with a needle-shaped electrode.

Your skin is a reflection of your general health and contributes to your personal image. If you have no specific problems that require professional services, whether you wear make-up or not, a regular skin care regimen is essential. While a skin care regimen can enhance your skin, a proper diet, rich in protein, vitamins and other essential nutrients, is the basis for healthy glowing skin. Other elements that can help you attain the look you want are: fresh air, exercise, plenty of sleep, lots of water, and protective or corrective skin care products. To maintain a good complexion, avoid overexposure to cold weather and high winds whenever possible. This can be the foundation for all around success.

Follow these easy tips regularly, using your favorite line of products and the results will be sensational:

Weekly cleansing should include steaming the face, as well as applying a facial mask to clean out and tighten the pores. A scrub, such as honey and almond, can be used on an alternate day in order to remove dead skin cells. Daily cleansing should be done with a cleansing cream or lotion. (Avoid using a bath soap. Bath soaps do not penetrate the surface of the skin for deep cleaning, and they often leave a greasy film on the skin). Specially formulated facial shampoos, or glycerine soaps can be substituted effectively. Apply your cleanser two or three times a day to the nose, forehead, cheeks and chin, massaging upward and outward in gently rotating motions with fingertips. Mix the cleanser intermittently with warm water, and remove with a clean damp face cloth or sponge.

After cleansing, rinse your face thoroughly with cool water. Then, using a wet facial sponge remove the final traces of cleanser. Now, to close the pores and firm the skin, gently apply an ice cube over your entire face once or twice. Blot your face dry with a white tissue.

Next, apply a freshener or toner for normal or dry skin, or an astringent for oily skin, using a cotton pad or ball. This is used in order to remove excess soil or oil remaining on the surface of your skin.

Moisturizing is vital, in order to maintain soft, healthy skin. Whether your skin is dry or oily, it should be moisturized (beginning in your

teen years) in order to attain a proper balance and to retain the skin's emollients. For example, moisturizers that contain alpha hydroxy acids (AHAs) are great benefit to the care of the skin. The AHAs (which are derived from acids in fruit, milk and sugarcane) loosen up the top layer of dead skin cells, slough them off and reveal your new fresh skin. If you plan to be outdoors for long periods of time, you should use a sun block (SPF) instead of, or in addition to a regular moisturizer for a stronger protection from the ultra-violet rays. Too much sun can cause irreparable damage and discoloration to your skin, if not protected.

Your lips need extra protection against the elements of the sun and in the cold weather, as well. After applying your moisturizer, you should use lip gloss or vitamin "A" over your favorite lipstick.

If you follow these few basics, your skin should feel soft and supple and have a healthy glow.

Notes

12

Shaping Up!

Good health, glorious hair and a glowing complexion are the rewards of a carefully planned diet. For starters, stay away from processed foods. Try eating wholesome, yet delicious food packed with fiber. Apples, grain cereals, tomatoes, peaches, grapes, carrots and leafy vegetables have fiber plus they're great sources of energy. For example, a great nutritional breakfast is a combination of low fat milk or juice, blended with a banana, nuts, fresh fruit and a protein powder. It's tasty, too! For a variety, experiment with a combination of fruits.

Combine herb teas and fruit juices for good vitamins, and drink lots of water. Eat plenty of vegetables (cabbage, spinach, green peppers, broccoli, zucchini, tomatoes, carrots, mushrooms) and instead of frying, broil or steam fish and poultry dishes. Cut down or cut out your intake of red meats. Avoid fatty foods, salt, butter and sugar.

As a daily supplement to your diet, a good vitamin program offers you great health benefits. It's sometimes difficult to get enough of a needed vitamin in the foods that you intake, so you should definitely research the benefits of those that you are lacking. Vitamin C, for example which is in citrus fruits and certain vegetables, gives you better resistance to a cold. Vitamin E, for example which is in whole grains, eggs, fiber, raw nuts, seeds and wheat germ cereal supports the formation of red blood cells that keep your energy flowing.

Changing your eating habits takes a lot of discipline, but if you motivate yourself it's easy to develop a new attitude toward food. Reduce your

food portions—try using a smaller plate and eat slower. It's better to stick with a normal eating pattern and eat the proper foods, than to go on a crash diet. There are some good diet pills on the market but before you try any you should always consult a physician. There may be side effects that you are not aware of. If you stay within these boundaries, you'll be eating better, healthier, and on your way to a more beautiful you.

Now that you're eating well, you can improve your body and become shapelier by finding the best type of exercise program for your career. Not only will exercise firm you, it will increase your circulation and provide you with more beautiful hair, skin and nails.

Choose the best time of day for your individual needs. Is it morning, noon or night?

If it's morning, an early morning jog or bike ride is a great way to start your day. Before beginning a particular exercise, stretch first. If you'd rather work out mid-day, many health clubs offer lunchtime classes. But don't skip eating. Carry crisp fruits and vegetables with you for a well-balanced diet. At night, of course, the possibilities are endless.

There's a wide array of classes for dance, swimming, exercise and nautilus and a countless number of facilities ranging from public gymnasiums to posh health clubs. Decide which one fits into your budget best. You may prefer to work out at home either alone or with a friend or hire a personal trainer. What type of exercise do you prefer? Is it calisthenics, isometrics, yoga, dancing (jazzercise and African dance are great), aerobics, step classes, slide, martial arts, jump rope, bike riding, jogging, walking or swimming?

These are all excellent choices which could easily fit within your personal exercise program. Whatever the case, spend at least an hour daily either at home, at a friend's home, at a health club, a local "Y" or wherever the opportunity allows.

Here are a few tips to help you get started:

1. If you plan to purchase exercise equipment, take it slow. Shop around for bargains but make sure that they're safety inspected and carry a good guarantee. Talk to the seller and try it out in the store to be sure that the equipment will work the areas of your concerns.

2. Joining a health club? Location is very important as the proximity of the club will affect your regular attendance—it should be either close to work or home. Make sure that the cost is not overwhelming and over your budget. Check out the staff and the other members to be sure that you're comfortable there. The equipment should be up to date and all trainers should be licensed. The hours of operation should be convenient and fit into your schedule.

3. For best results, be sure to do moderate to vigorous exercise no less than four times a week Once you are at a comfortable weight, curtail your eating habits and regulate your exercise regimen.

4. For low-budget home work-outs, get an exercise mat. This will be great for comfortable floor exercises such as sit-ups, bicycle crunches and leg lifts, to tighten abdominal muscles. And to firm the upper torso, weights will be the perfect tool for shoulder presses, biceps curls and deltoid lifts. Put on some great music and work out! Total cost for all this is about $25.

5. If you live or work in a building with lots of stairs, get acquainted with them. Lunchtime is the perfect time to put on your sneakers and take a hike. It will do wonders for your legs, thighs and hips.

6. Racewalking is a great way to firm your hips and buttocks and tighten the muscles in your legs. Start slow (30 minutes, 3 times a week) with about a mile a day and build up to 10 miles for great results. Its fun to walk with a group or trainer, or find a racetrack near your home where you'll run into other folks like yourself. Be sure you purchase a good walking shoe for comfort and to prevent injury; and always warm up before you walk

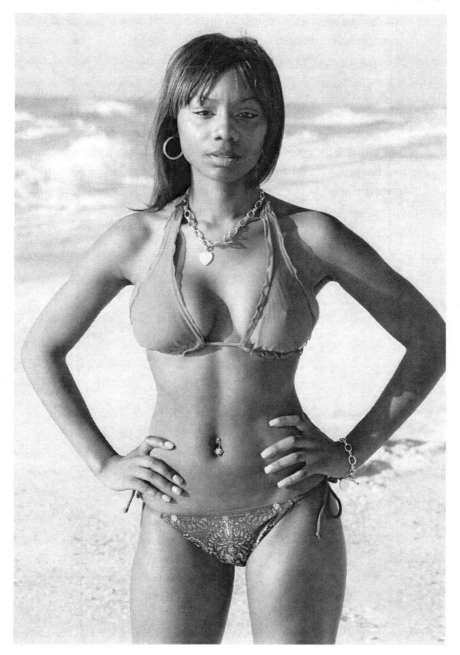

with squats, stretches and lunges. Set your own pace and most importantly, be consistent.

Now, if you're ready to control your eating habits and to involve yourself in a regular exercise program, then you have the discipline to become a model. It's your choice, if you become dedicated to exercise and dietary discipline, you'll experience a new physical and mental energy almost immediately, not to mention the social benefits that you'll enjoy as well. So, start today! Make a commitment to get yourself in shape for a lifetime of good health and glowing beauty.

Desirable Weights For Models

Height	Weight	Dress Size
5'2"	100-108	(Petite Models) 4-6
5'3"	103-111	
5'4"	106-114	
5'5"	109-117	(Short to Average) 4-8
5'6"	112-120	
5'7"	115-123	(Average / Workable): 4-8
5'8"	118-125	
5'9"	120-127	
5'10"	122-129	(Tall / In Demand) 4-8
5'11"	123-130	

If you wish to model, and you find that you are above the desirable weight, then you must set your goal and make a serious commitment. As a model, you must be motivated and willing to make a lifelong change for the better, both in the types and the amounts of food you eat, and in the attitude that you have toward food in general.

Now that's discipline !!!

No Substitutes Diet

If you are overweight, here's a good diet for you (for two weeks only). During this period, be sure to drink at least eight glasses of water a day. Sustain from anything not included in the diet, and be sure to eat only what is in the diet and all of the foods assigned rather than doing without …..

1. No eating between meals
2. All vegetables seasoned without butter
3. All salads without oil
4. Lean parts of meat, coffee black or tea clear

Breakfast: (The same every morning) 1 or 2 eggs, black coffee, grapefruit

Monday: Lunch–2 Eggs, tomatoes, black coffee or clear tea
 Dinner–2 Eggs, combination salad, 1 piece dry toast, grapefruit, tea

Tuesday: Lunch–2 Eggs, spinach, tomatoes, tea
 Dinner–Steak, tomatoes, lettuce, celery, olives, cucumber, tea

Wednesday: Lunch–2 Eggs, spinach, tomatoes, tea
 Dinner–2 Lamb chops, celery, cucumber, tomatoes, tea

Thursday: Lunch–2 Eggs, spinach, tea
 Dinner–2 Eggs, cottage cheese, 1 piece dry toast, grapefruit, tea

Friday: Lunch–2 Eggs, spinach, tea
 Dinner–Fish, combination salad, 1 piece dry toast, grapefruit, tea

Saturday: Lunch–Fruit salad (Put everything in it and eat all you want)
 Dinner–Plenty of steak, celery, cucumber, tomatoes, tea

Sunday: Lunch–Cold chicken, tomatoes, grapefruit, tea
 Dinner–Chicken tomatoes, grapefruit, carrots, cabbage, tea

Weight should drop about 20 pounds in two weeks. Basis of diet is in the chemical reaction and maintenance of normal energy while reducing. Quantities are less important.

Vitamins and How They Work

VITAMIN D CAN BE ABSORBED IN THE SKIN BY EXPOSURE TO SUNLIGHT AS WELL AS BEING FOUND IN CERTAIN FOODS. With its exception, vitamins (13 in all) which are organic substances essential to good health, are derived from animal and plant foods. IN ADDITION TO VITAL CHEMICAL REACTIONS IN THE BODY, they help release energy to the body from carbohydrates, fats and proteins in the foods that you intake. Below are those essentials and how they work:

VITAMIN A aids new cell growth and keeps tissues healthy. Essential for vision in dim light. Found in egg yolks, fish, milk and butter.

VITAMIN B1 (thiamine) converts sugar and starches into energy. Aids in functioning of the nervous system. Found in whole grains, dry beans, peas, fish and lean meats.

VITAMIN B2 (riboflavin) helps the body obtain energy from carbohydrates and proteins. It's found in milk, cheese, eggs, fish and leafy green vegetables.

VITAMIN B3 (niacin) works with other vitamins to convert carbohydrates into energy. Found in liver, lean meats, peas and dry beans.

VITAMIN B6 assists in the metabolism and synthesis of proteins, fats and carbohydrates. Found in liver, whole-grain cereals, potatoes and meats. VITAMIN B12 contributes to the development of red blood cells and the functioning of the nervous system. Found in liver, kidney, lean meats, fish and milk.

VITAMIN C (ascorbic acid) promotes tissue repair; helps form connective tissue, bones and teeth; and aids in resistance to infection. Found in oranges, broccoli, strawberries and potatoes.

VITAMIN E supports the formation of red blood cells and preserves tissues. Found in vegetable oils, eggs, dry beans and whole grains.

VITAMIN K helps blood clot. Found in spinach, liver, lettuce and cabbage. BETA-CAROTENE is an antioxidant that supplies the body with vitamin A. Found in richly colored orange and yellow fruits and vegetables. FOLIC ACID helps the body manufacture red blood cells. Needed for cell growth. Found in leafy green vegetables, beans, nuts, oranges and whole wheat.

Beauty—A Dozen Quick Steps To A Model's Natural Look

1. Cleanse your face thoroughly with a cleansing lotion or cream. Follow-up with the application of astringent or toner applied with a cotton pad.

2. Moisturize your face for protection. Using a product which contains sun block is highly recommended to protect your skin from harmful rays. Moisturizer will lead to a smooth application of your foundation or make-up.

3. Apply foundation as your first step to a professional make-up look. Be sure to use a color that has been tested on your skin. A perfect match is one that blends in without showing a trace of make-up, but rather looks like your natural skin-tone. Oil-bases should be avoided for modeling. Make-ups that have a water-base are best or the cream-to-powder foundations work well on all skin types. In any case, the blending is essential—there should be no color-line or difference in the skin not covered by make-up. When applying your foundation, use a damp cosmetic sponge for best results, gently blotting the product onto your face all over and blending it right down into the neckline. This method will assure you of an even, consistent application. If you are being photographed, the coverage must be flawless. For this situation, particularly if you have blemishes or discoloration, a creme foundation will give you the best results.

4. Cover stick, concealer or highlighter is the next step for your enhanced natural look. This comes in a tube like a lipstick or in a creme-base in a compact. Apply the concealer to problem areas under your eyes, on laugh lines and dark spots to lighten or blend them to your natural tone. Using your finger or an applicator will work for the application, but blending should be done with a sponge using neat dabbing motions.

5. Powder is the next essential for your model's look. It will assure you of a long-lasting matte finish. Translucent powder comes generally in several shades of brown. Select one that is slightly lighter than your complexion—it will warm to your body temperature and blend in without showing. The best way to apply translucent powder is with a large powder brush or a big fluffy powder puff. Using the powder sparingly, dust it over the entire face. Translucent means clear, and if applied properly it will keep you from shining—this is essential when you are on camera or working in any capacity as a professional model. The loose powder is better for your initial application, but if you need a quick touch up, carry a compact with the same color powder, but be sure that you don't cake it on as you apply it.

6. When it comes to your eyebrows, you may want to consult an expert in order to decide the best shape for your face. Another criteria to consider is to know what eyebrow look is in—thick and bushy or thin and wispy. In any event, keep your eyebrows well groomed. Brush them daily with an eyebrow brush and observe their basic shape. If your eyebrows are connected above the bridge of your nose, by all means, wax, tweeze or clip them and remove any other stragglers under the arch. Shaving is not recommended.

Once you have groomed your eyebrows, if you would like a fuller look, fill them in with an eyebrow pencil that matches your natural hair color or brows and then brush them again to blend in the pencil strokes. If you have bleached out your hair drastically, however, you may wish to use a cream bleach on your brows designed especially for lightening facial hair. You can keep your brows neat all day by applying a quick touch of clear mascara or brow gel.

Remember, your brows are like the frame to your face—they can open your eyes, making them wide and wonderful, or close them, drawing them together too much. The length, thickness and shape are your determining factors. Take your time, make changes slowly and cautiously.

7. Give your eyes the pizzazz they need with the application of color accents. There are three steps which you should practice. Select a primary color (smokey shades are always flattering) and then coordinate it with a light (highlight) shade and a dark (accent) shade. First apply the highlight right under the arch of the brow. Then apply the primary color, starting at the lid and blending it right up to the highlight shade. Finally, contour or accent the crease of the eyelid with the darker shade. The colors should not be separated, but should be blended as they meet. For the eyeshadow applications, brushes or sponge applicators will work well —it's your personal preference.

8. Contour comes in creme and powder formations. It is used to sharpen or sculpt particular features of your face by minimizing their size with a darker shade of make-up. Most people use contour to change the illusion of their nose, jaw line, forehead or to lift their cheekbones. Experiment with the different ways your face can look. Apply creme with a sponge or brush on the powder in the specific area. For best results, be sure to blend well.

9. Now you're ready for blush. Again creme blush requires a sponge applicator, powder requires a brush. When you apply, your blush, avoid bringing it too close to the nose—hold two fingers next to your nose, then start the application from that point. Always, stroke your blush along the cheekbone and blend into the contour or hollow of your cheek. Do not go beyond this area. Use a color that is flattering to your complexion—avoid extremes of light or dark, and consider the clothing choices that you will be wearing for proper color coordination. Once you have completed the application of your blush, re-apply translucent powder to your entire face.

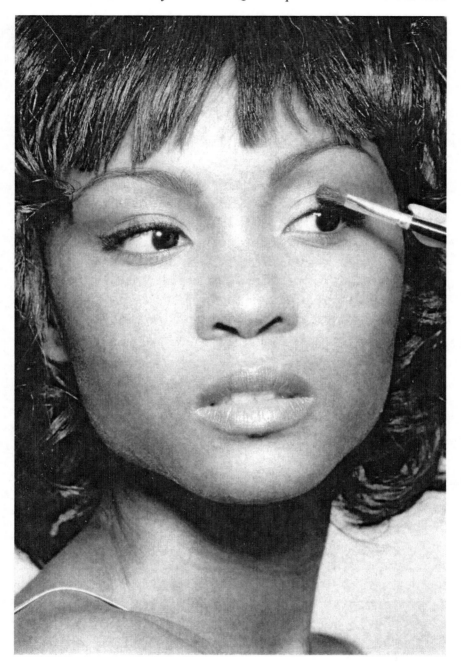

10. To add more depth to your eyes and for a more exotic look, trace the perimeter of the eyes with a liner. Pencil, liquid or powder liners come in an array of rich tones. Your look should never be too harsh. Black is popular, but nor always best. Try lighter liners first in shades that compliment your eyeshadow—blue works well to make the white of your eyes brighter. For a more demure look, instead of tracing the entire eye, start in the center and end at the corner.

11. Great lashes can complete the picture, giving you sensational eyes. The secret is to keep them as natural, yet full as possible. Try your hand with an eyelash curler—it can make your lashes look extra luscious and you'll get better results from your mascara. For routine days, use mascara for lengthening and thickening your lashes in black, brown, navy or clear. Have fun with your color choices and stick to a color theme. For best results, apply your mascara, first brushing the wand across the lashes, then brushing outward and upward to thicken the lashes—two coats are recommended for setting the shape. For modeling assignments, you will need to find a style of false lashes that you are comfortable wearing. They are available in many lengths, shapes and thicknesses—the rule of thumb is comfort and contour. If you plan to wear false lashes, be prepared. Buy several pairs and practice applying them. First, if necessary, cut them to the correct length. For best results and to serve as a guide, always line the eyes first. Then apply the glue— remember less is better—use a straight pin, toothpick or cotton swab to put the glue on the lashes. Finally, hold the lash in the center to gently adhere it and, with your index finger, tap it into place, adhering it from corner to corner.

12. Luscious lips can make a model memorable. To master the art of lip design, start with a lip liner in a color that matches your lipstick or go off-beat with a shade of brown. Trace around the perimeter of your lips, and unless you want to make your lips appear fuller or thinner, keep the liner just inside of the outer edge. By applying lip liner, you will have a neater appearance and it will also prevent your lipstick from bleeding. You should

use a lipbrush now to apply your lip color. Matte lipsticks have great staying power, but if your lips tend to be on the dry side, use a lip conditioner first. Sheer shades such as pinks and beiges are always nice and natural. The most popular types of lipstick are the cream formulas or shimmery shades. Whatever your choice, if you wish, follow-up with a lip gloss or sheen as a nice finishing touch.

Now that you know how to apply your make-up, here are some suggestions regarding the intensity of color and the techniques that pertain to certain situations:

When you go on a go-see, you should wear little or no make-up. (This is why a good skin care regimen is essential). Most casting directors want to see you "naturally". Your portfolio will serve to stretch the imagination.

Make-up for television should be very light and natural and more like a daytime look. Be sure to powder well, because the lights are extremely warm and you don't want to appear too shiny.

Runway modeling calls for a heavier touch because under the spotlight, colors tend to wash out. So you can be generous with your application.

For photos, lean on the more natural side when shooting color film. Black and white photos should be taken with more concealer and contour than usual because of the shadows that are created.

Most other jobs, such as showroom and fit modeling call for a dramatic daytime look.

Make up for trade shows is usually determined by the product or service that you are representing.

Make-up for videos has no specific rule, so be prepared to listen well to the director for instructions on the look that you should portray.

Print modeling also has many variables, ranging from office products to fast food to beauty, and more.

Be prepared for every assignment. Always listen well for the look that you'll be expected to have and be ready to achieve it.

In all cases, it is very likely that a make-up artist will be available to you; but always carry a full line of colors and know how to create the looks that you might need. Remember, practice makes perfect.

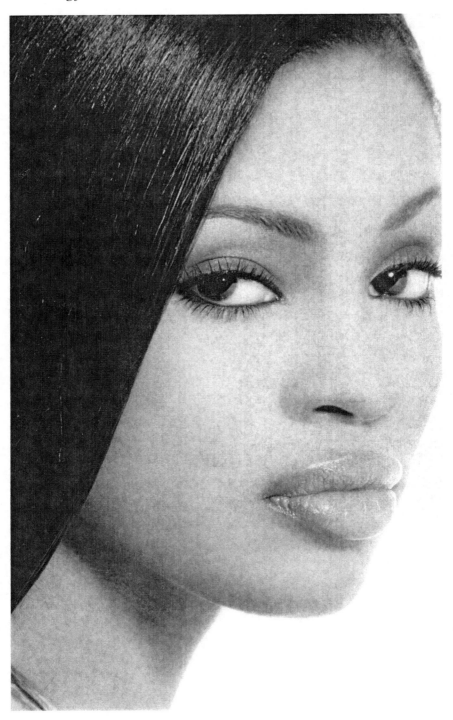

<div align="right">

14

</div>

How to Achieve the Illusion of Perfection

Did you know that your hairstyle can help you achieve the illusion of perfection? Stand in front of a mirror. See which shape your face is and follow this guide to maximize your best features.

1. ***Do you have a low forehead?***
 Avoid bangs. You can lengthen your face by softly layering your hair and brushing the top and sides upward and out.

2. ***Do you have a high forehead?***
 Use straight lines along the sides of your face and across the forehead in a bang. This look will shorten and balance the face.

3. ***Is your chin narrow?***
 Longer hair works best here. To balance out a receding jaw line, try waves, flips or curls that fill out around the chin line.

4. ***Is your chin full?***
 For this facial type, shorter hair works best. Soft curls that add fullness to the top and sides will soften and balance out your chin line. Be sure to brush the hair away from the sides of the face and chin.

5. ***Is your face round?***
 Middle and side parts will lengthen and slenderize a round face. Straight or slightly wavy hair is a good choice here.

6. ***Is your face angular?***
 Chin length curly or wavy hair will work wonders for your facial features. Keep your hair as full as possible, but avoid closing in the face.

See which of these illusions works best for your facial features.

Which one are you?

Oblong: For an oblong face, choose soft rounded styles which do not lengthen the face. One such method is to have a feathery bang. Hair looks best at jaw length, full and off the face. If you decide to wear your hair long, avoid a straight look.

Oval: An oval face is considered to be the perfect model shape. Just about any hairstyle will fit the oval face's balanced features. Choose a style that best suits your hair texture and type. Your choices can include bobs, braids, weaves, curls, waves or straight looks.

Round: If by experimenting, you've found that you have a round face, you should build as much height as possible with your hair—this will give the look of length to your face. Avoid framing your face with too much hair, particularly with thickness at ear-length. Clean, straight lines will contour and slenderize your face. An excellent choice for a round face is a bob cut.

Square: If you have a square face shape, you should soften the lines both on your forehead and chin by having your hair fall gently to those areas. Assymetrical styles, layered cuts or softwaves work well to flatter the squareness of your face.

Heart: For a heart-shaped face, you may opt to wear a flip with a softcropped bang. This will give an illusion of fullness in your cheek area

Pear: To add balance to a pear-shaped face, wear your hair short and full. Keep it cropped at ear length for best results.

15

Tips To Help You Get The Best Look For Your Special Features

Know what works for you:

- o Dramatize a small nose by choosing a style that creates back interest.

- o Minimize a large nose by choosing a style that curls toward the face.

- o A short neck looks longer if hair is swept up and away from the face.

- o Soften a prominent chin by adding height at the top and fullness at the sides.

- o To distract attention away from a double chin, select a style that sweeps hair up and off the face.

- o Smooth, simple styles look best with glasses. Avoid fussy or severe haircuts.

- o To make a small face look larger, brush hair up and away from the face.

"Easy To Do" Styling Suggestions:

o For a shaggy, wind-blown look, fingercomb through your hair.

o To form tendrils, draw out strands and brush around finger.

o To eliminate tangles, brush hair first and comb through with a large wide-tooth comb.

o To form large, open curls, separate thick strands and brush over finger.

o For soft, feathery curls, lift each curl individually and back-brush slightly.

o Create casual bangs by using the tip of a rattail comb. To brush long hair correctly, hang head down and brush from nape of neck to ends.

o To revive a style which has already been sprayed, wet with a damp comb and comb into place. When dry, spray lightly.

Special Tips For Setting Your Hair:

o For a smoother set, always use end papers.

o Before setting, and to eliminate tangles, use a setting lotion or creme rinse. It will control curliness or add body to fine, limp hair.

o In sectioning the hair, allow about an inch-wide section of hair for each roller.

o Medium-sized mesh rollers are the most popular size to use. Take each section, and cover it with an end-paper before rolling. (The endpaper should extend slightly beyond the ends of your hair).

o To avoid separations in the finished set, wind rollers as closely as possible.

o When winding rollers, make sure that each section of hair is flat and smooth.

o Use a light tension while rolling the hair and firmly secure it with a roller clip or hairpin.

o For hair of normal texture and thickness, use medium rollers for styles with some bounce.

o For smooth rounded styles, use large to jumbo rollers.

o In making clip curls, try to keep each curl uniform. To prevent fish-hooks, use end papers when making clip curls.

o To set a flip for extra hold, try a setting lotion or gel. After it dries completely, brush thoroughly to remove any signs of residue.

o To make a simple cheek curl, dampen hair slightly and tape with cellophane tape.

Cutting Is for Professionals:

o Regular trims (every 6 to 8 weeks) keep your hair healthy and hassle-free. Split ends, if left to chance, will cause excess breakage and damage to your hair.

o Expert shaping is a must for wiry, hard-to-manage hair.

o Blunt cutting is best suited to fine, limp, and long hair.

o The tapered cut, a method of removing excess bulk by tapering each strand to a point, is ideal for thick, coarse hair.

o Before you cut or color your hair, it is recommended that you go to a store and try on wigs so that you can see how you will look in the style that you are considering.

Add Some Pizzazz to Your Style:

o After your stylist cuts your hair, you may wish to try a little color to add glamorous highlights to your new look.

o Liven up dry, listless hair with a hair spray enriched with lanolin. For short, relaxed styles, try a gel pomade—results will be a glistening sheen and lots of control.

o Sprays with super holding power are best suited for wiry or flyaway hair. When spraying hair, keep the container at least 10 to 12 inches away from the head. If you spray, always do it after you curl—the heat could bake in the spray and lead to breakage. Be sure to oil or moisturize your hair at the end of the day to keep it soft and flexible.

o Hair pieces can be very appealing to add versatility to your look. A chignon, upsweep, top knot or ponytail, for example, will give you a complete range of effects, from sophisticated to casual.

o Wigs are not good for every-day wear. They are merely to give you special styling versatility.

o If you do decide to wear a wig, find the best color and style for your face shape and blend your own hair into it when you comb it.

Take Care of Your Hair:

o Revitalize dry, split ends by rubbing tips with a little conditioner.

o Don't burn your hair by using too much heat from curling irons and blow dryers.

o Be cautious about at-home perms and color treatments. Using these products together or too often can result in major hair loss.

o Always use a special shampoo formulated for your hair type—oily, dry, color-treated, etc. Using one that has detanglers is the first rule of thumb. Make sure that it states a pH level between 4.5 and 5.5 points and that it has moisturizers in it. Finally, your shampoo should be mild to your scalp and eyes..

o Long hair requires more conditioners and special rinses than short hair does.

o If you have dandruff, don't add extra oil to your scalp—dandruff is caused by excessive oil production, not dryness. Be sure to use anti-dandruff products, and if the problem persists, you may need to talk to a dermatologist. Your hairstylist should be consulted for guidance on home-care as well.

o Be sure to brush oily hair often, too, as it prevents oil from collecting on the scalp.

o Natural bristle brushes are the best bets. To wash natural bristle brushes, swish around in hot sudsy water, rinse and dry face down on a towel.

o If you swim, be sure to cover your hair and shampoo and condition it as soon as possible. Chlorine, in particular, can be very damaging to your hair, causing dryness which leads to breakage.

Special Tips to Care for Your Braids and Extensions:

o Hair extensions give you natural good looks, but remember to give them the required care that they need.

o For home maintenance, be sure to use conditioning shampoos and massage the scalp gently with the balls of the fingers—not the nails.

o Rinse well several times to remove all traces of shampoo and then wrap a towel on the head to absorb the excess water.

o To complete the drying process, blow dry on low heat or let it dry naturally.

o Then oil the scalp and use an oil spray as needed in between shampoos. Stick to light oil based products, rather than heavy moisturizers that may weigh down the hair and lead to breakage.

o At night, wrap your head in a silk scarf or sleep on a satin pillowcase to prevent breakage from excessive friction.

o Most extensions or braid styles will last two to three months with proper maintenance.

o For durability and best results, however, salon maintenance is recommended at least once a month for all braids, extensions and locs.

o If you want to look your best, start at the top and take control of your coif. Be sure that you keep up with the latest hair style trends as dictated in your current fashion and beauty magazines.

o Working models are expected to have fabulous hair at all times.

o Whatever styles you choose, consider foremost your age range and your type. This is a very important part of marketing yourself. And, before you take your pictures, rehearse at home in front of the mirror. Note your best angles and facial expressions, and study your wardrobe changes. Be adventurous!

Treat Your Feet to Beauty

Looking good is always easier if you feel your best. Your appearance counts from head to toe, and your feet play an important role in your overall presentation. As a model, you should be ready and able to wear all styles of footwear including the barest of sandals. So let's start with a pedicure; try this weekly foot care regimen. Take note and enjoy the benefits:

1. Give your feet a five-minute soak in warm soapy water. If your feet are very dry, try a little baby oil in the basin too. There are also commercial solutions on the market if you prefer.

2. Gently scrub your feet with a "Buf-Puf" non-medicated cleansing sponge to remove rough spots and flaky skin. If the skin on your heels has thickened, regular scrubs with a pumice stone will help to soften it.

3. After cleansing, dry your feet well. Be sure to wipe between each toe.

4. Apply cuticle oil to your toes, massaging well. Then push back the cuticles with a cotton tipped orangewood stick.

5. Dry your toes again, then clip them squarely with a toenail clipper. The nail should end at the tip of the toe.

6. Polish your toenails, first with an undercoat, then with two coats of your favorite nail polish (a basic shade is best for modeling assignments). Finally, apply a protective clear top coat.

7. After the polish dries, massage your feet with a moisturizing lotion, cream or oil (jasmin is wonderful) for a luxurious finishing touch. If your feet are extremely dry, apply Vaseline at night and sleep in white cotton socks. In a few weeks, they'll be like new.

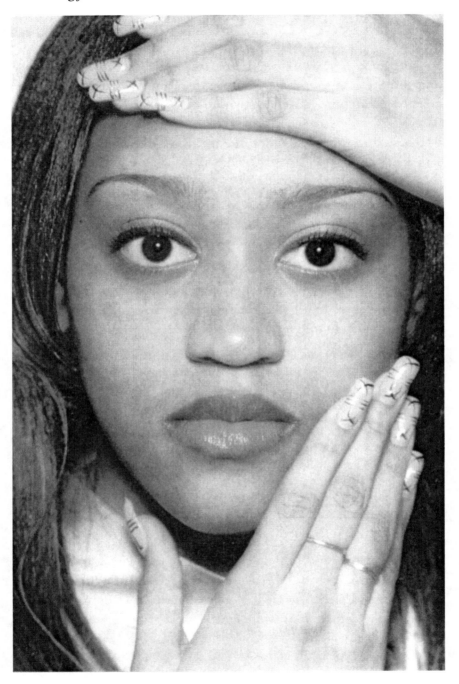

Quick Nail Tips

First of all, protect your nails. Whenever you do household chores, wear rubber gloves. You'll need protection while cooking, since certain foods such as lemons and onions can weaken your nails. Using lotions regularly offers some resistance to harmful chemicals, and massaging the lotion into your nails will strengthen them. And watch your diet! Well balanced meals are most important to the health of your nails.

Now that you know how to protect your nails, you should understand how to beautify them. Follow these quick steps for a perfect at-home manicure, at least once a week:

1. Prepare a well-lighted area by spreading out and arranging your tools neatly. You'll need emery boards, orangewood sticks, a nail brush, a buffer, a small bowl, a small towel, polish remover, cuticle oil, cotton, base coat, nail polish and top coat. It seems like a lot of supplies, but you'll use every one of them.

2. Remove old nail polish with cotton moistened in an oil-based polish remover, or try dipping your nails into a remover.

3. File your nails with an emery board, in one direction only (back and forth motions can lead to peeling). Oval is the best shape for a model's nails. Avoid filing deep into corners, since this weakens your nails. Also avoid using a metal file—leave the tough jobs to the professionals.

4. Soak your nails in warm, soapy water. Then, dry with a soft towel, gently pushing back the cuticles as you go.

5. Apply cuticle oil or a specially formulated oil treatment to the cuticle area. Massage gently, using firm pressure to soften the entire area. Then, with an orangewood stick wrapped in cotton and moistened in oil, push back the cuticle as much as possible without forcing it.

6. Clean your nails in warm, soapy water (not too hot) by brushing in downward strokes with a nail brush. Also, clean under the nails with a wet, cotton-tipped orangewood stick. Towel-dry nails, being careful not to leave any dampness. Buff the tip of the nail to smooth it out.

7. Polish your nails correctly. The polish should leave your nails hard, though flexible, and colored with a sheen. One type of coating can't do it all. You'll need a base coat, two coats of polish, and a top coat. A base coat protects your nails, keeping them flexible and more resistant to breakage. A quality nail polish will keep your nails from splitting and chipping.

To correctly apply polish, dip the brush into the bottle once. Then run the brush along the bottle's edge to remove excess polish. First stroke the brush down the center of the nail, then once along each side. Three strokes should be sufficient for a professional looking manicure. For modeling, it's best to select neutral or natural colors unless the assignment you're on specifies certain colors. A top coat promotes hardness, adds sheen and keeps your manicure looking fresh. For extra protection, polish under the tips of your nails as well. This reduces the exposed surface area and makes the nail tips more durable.

Notes

Take Time Out—Cleansing The Mind And Body

Beauty Bath Or Aromatherapy

To assure a softer skin all over, in addition to your daily shower or bath, take a weekly "beauty bath". Soak in hot (but comfortable) water for at least ten minutes and add baby oil or a favorite fragrance such as jasmine oil to the water to soften and moisturize your entire body. Or, you may wish to try bath salts or sea salt for a purifying or deep cleansing effect. Because of the softening effects on the skin and nails after your beauty bath, it is a great time for a pedicure and manicure.

Spa Treatments, Body Wraps and Massages

All of the above are intended to relax, purify and tone the body. Find a place near home that offers these services and plan a monthly treatment in your budget.

Get Your Beauty Rest

Be sure to find the time for a good night's rest. If your schedule does not permit eight hours, fit in time during the day to nap or "shutdown". Proper rest is vital to your health and beauty maintenance.

Meditation and Spiritual Healing

Find a quiet place to pray and meditate at least once a day—fifteen minutes can be very rewarding. Candles, incense and soft music are great companions which can add to the relaxation process.

Fragrances

Complete your model's presentation with your favorite fragrance. It should compliment your mood and captivate your audience.

Avoid too strong scents that overpower you—it should be just enough to be pleasing and have a slightly lingering effect. When you find the fragrance that does all that, spray or dab it on your wrists, the curve of your neck and behind your ears—the pulse points are perfect. Stick to one fragrance—never mix your scents. A note about fragrance: use caution in wearing fragrance when you are modeling designer fashions—the scent will linger in the clothing and the oil may cause damage to the fabric.

Visual Poise Means Great Camera Work

All models should possess poise. Poise is a basic ingredient of charm. Poise includes many things, but a large part of "visual" poise is graceful movement. A young woman possessing the qualities of grace and poise will surely be admired. We want you to gain inner poise and assurance through confidence in your outer poise.

Here, we've outlined some important factors necessary in displaying grace. We explain how to stand properly, enter a room, how to sit gracefully, how to go up and down stairs with confidence, and how to handle your gloves and fashion accessories with ease. Above all, these simple steps will bring striking beauty to your figure in motion.

Graceful Standing

Right Hesitation:
Place your left foot at a 40 degree angle Place your right heel out front against your left instep. Your right toe should be pointing straight ahead. The weight should be on the left foot. Both knees should be bent very slightly. There should be absolutely no space showing between your legs.

Left Hesitation:
This is the same as the right hesitation except feet are reversed (left foot in front pointing straight ahead, right foot in back slightly angled).

Left and Right Model's Stance:
This is the same as the hesitation, except the heel does not touch the instep. The forward (straight) foot should be 3 to 5 inches in front of the rear (angled) foot.

When stepping out of a hesitation or stance, always lead with the forward foot—the weight is on your back foot and will keep you balanced and graceful.

When walking into a hesitation or stance, always place the forward foot first and then close in with the back foot, shifting the weight to the rear as you stop.

Graceful Hands:

A graceful hand is a relaxed hand. The feminine hand should be seen in profile and with lovely curved fingers. Below are some of the most popular suggestions.

Hand Positions:
1. Hands always look good at the sides with palms facing inward toward the body.
2. Hands can be placed along the waist with palms facing in and one hand resting on the other.
3. Hands can be placed on the hips with fingers angled downward toward the floor.
4. Fingers can be clasped or laced with one wrist lowered. Laced fingers can be placed either at the hip or waist.
5. Hands in pockets with thumbs out.
6. Thumbs in pockets with hands out.

Walking Up and Down Stairs Gracefully:

o Place your entire foot on the stair whenever possible.

o It is very important to keep your knees bent when you are on the stairs. Never bob up and down.

o Maintain a smooth, flowing motion.

Graceful Sitting:

How to Sit:

- o A poised young lady knows how to sit down, and what to do with her hands and feet when sitting.
- o When approaching a sofa, chair or bench you should never bend over at the waist.
- o Always back into the seat and bend your knees, lowering your body slowly.
- o Keep your back straight as you sit.
- o If necessary, as you are lowering yourself into the chair, place your hands on the chair to support your weight.

Foot Positions:

The hesitation is one of the best positions–it's the same foot placement as if you are standing.

Crossing your legs should be done so that there is no way reason for the viewer's eyes to wander. You should cross one leg over the other, resting the top leg on the knee of the bottom leg, and angle your body toward the direction of the top leg. If your legs are not long and slender, crossing them is not usually very attractive.

Crossed ankles are always attractive. When you do cross your ankles, however, always keep your knees together and tilt your legs in the direction of the ankle on top

In the crossed legs or crossed ankle position, your body should form an "S" curve. Soft angles are always more graceful. There should never be a space between your legs when you are sitting down.

Hand Positions:

Hands should always be placed softly on your lap or on the forward leg when you are sitting. These are a few positions that we suggest:

- o Palms together—one up, one down.
- o Palms together—both facing up.
- o Laced or clasped fingers.

18

Plan Your Portfolio–
You're Almost Ready

We've discussed your diet, your hair, your wardrobe, and everything significant to the development of your modeling career. Now that you've come this far, let's go all the way. Get ready to capture your new model's image. Let's plan your photoshoot!

Your portfolio is your key to success as a model. If your portfolio is not interesting, updated, and professional looking, then you must spend some time and money to make it so. Showing it to prospective clients and gaining their interest is the path that leads to your getting booked. Leaving a composite with that client reminds him or her of your modeling potential and if not at first sight, you may get booked down the line because you're in the client's models file. You should work hand in hand with your agency–either they send out your book or you carry it on "go-sees", the same system works for your composites. Many models, although it's an extra expense, will have two books for this reason. It might be a good idea to do the duplicate as a condensed (meaning smaller) version. And, if you work both as a commercial and a fashion model, keep your looks and books separate.

A model's book or portfolio can be either leather or vinyl with or without handles. It has plastic sleeves and holds 8 x 10 photos. As you begin to get print bookings, you should add "tear sheets" or copies of your ads or editorials to your model's book. Showing a diversity of looks is important, such as: casual daytime, business, evening or formal and

swimwear. Once you've selected the pictures for your portfolio, choose two or three to use on a composite which best represent you as a model. A composite is a card with a group of photos (one should be a headshot) which should bear your name, your statistics (measurements, height, clothing and shoe sizes) and a contact phone number. If you do not have an agency yet, you should hire an answering service (they charge about $25 a month and will call you with urgent messages)—never give out your home phone number.

Freelancing (on your own) may be a good way to get started in modeling, and to gain the necessary experience; but an agency can protect you and help you earn more money in the long run. No agency will send you out on an interview or a go-see, however, unless you have a portfolio and composites. What are composites? A composite is a grouping of two or more of your best pictures, combined on a single card or folder. They can be either black and white or color. If you are just starting out, it is always better to use black and white, because of the expense of color.

First, look for a good photographer. Ask for references in a city near your home or take a daytrip to a major fashion city, such as New York City, Chicago, or Los Angeles. Most importantly, find someone who is familiar with shooting models and fashion, not a family photographer who shoots weddings and babies. Don't make a commitment until you've studied his or her portfolio, and make certain that you are comfortable with this person. Observe the different models in the portfolio. Do they compare to the pictures that you've seen in newspapers and magazines? Does the studio look neat and orderly? Are the prices right? Ask about testing. Testing means that the model pays only for the film and processing and the photographer directs the photoshoot in order to update his or her portfolio as well as yours. Two photo sessions are recommended if you are just a beginner the first session for headshots only; the second for fashion shots (full-length).

Head shots are the most comfortable to begin with when you are inexperienced. Make-up, hairstyling, accessories and the type of neckline that you select for these shots can make all the difference in a good photo or a bad one. So, don't waste your time or money; if you don't apply your

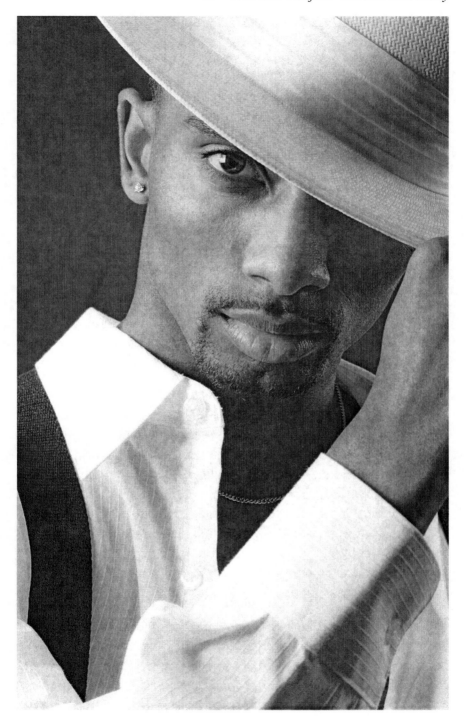

make-up well, hire a make-up artist. Your photographer should be able to recommend one to you for about $50 per session.

Be versatile with your hair…don't wear it the same way for all of the shots. Style your hair according to your facial structure, your age, your personality, and your attire… and avoid a new and unfamiliar haircut unless your hairdresser will be with you at the photo session. Practice styling your hair at home first, and be sure to bring all of the necessary tools with you, in order that you can work fast and efficiently. By tools, I mean: curling iron, blow-dryer, hair pins, combs, brushes, rubber bands, gel, mousse, and hair spray. You might even wish to bring a hat. Wigs are not recommended, because you're selling you..naturally.

For a casual daytime or business look, your jewelry should be small and simple, and you should wear an uncluttered shirt such as a scoop-neck, cowl-neck or a tailored style. For a more sophisticated or dressy look, try a lacey collar with rhinestone or pearl earrings, or a v-neck or one-shouldered blouse with an elaborate necklace; and don't forget to dress up your hairdo. Remember, you want to give the appearance of having a long neckline, so don't clutter!

After you've warmed up by taking your headshots, you're ready to venture into full-length. Movement and body control are extremely important for these pictures. Your hips should be tucked under at all times, and your stomach held in. Your neck should be elongated and your shoulders held back. These positions require a lot of exercise and practice, preferably in front of a full-length mirror. If you do not feel relaxed or confident, you'll be wasting your time and money, so practice until you do. Look in fashion magazines and imitate the models that appear on the pages—note their foot positions as well as the body contours, hands, neck and facial expressions.

Don't rush out and buy new clothes for this photoshoot. Take your favorite things from out of your closet and select the ones that make you feel the most exciting. They should accentuate your figure and compliment your complexion. Take an outfit for business, fun, daytime, evening, swim and perhaps loungewear . . . keep your accessories

minimal. Remember, you are the star. Your clothing selections must not overpower you; they must enhance you.

You may use the same photographer for both sessions if you are comfortable with him or her; but try a different one next time, in order to create a variety in your portfolio, and for the experience of working with different professional teams. Your first two sessions should cost you no more than $300 combined.

Get Plenty of Sleep the Night Before!!!!!

19

Photo Reproduction

One of the most important tools that you must possess as a model is a good supply of composites. Depending on the quantity and quality, you should expect to pay anywhere from $150 up to $2000 to get started. Of course you should also take into consideration whether you are going to print in black and white or color. Color works best, but of course, black and white is very acceptable for new models. You may even choose to mix—for instance a color head shot can be on the front, and black and white full-figure shots can be on the back.

Whichever type of composite you choose, be sure to include your statistics: your name, agency (if you have one), union affiliation, statistics (bust, waist, hips), dress size, shoe size, hair color and eye color. Once you've been accepted into an agency, your agent will advise you on the best type of composite to get, how to lay it out and how to understand the cost structure.

Here is some pertinent information which might help you to make a decision:

Laser composites are quite popular and they can be reproduced quickly from a color slide or transparency. If you're ordering a small quantity, this can be the most affordable color composite to start with. Laser composites are available in paper stock or card stock.

Offset Printing generally requires a large run of composites (at least 1000). They can be ordered in color or black and white in card stock.

The pricing is compatible to the high quality of the printing and the card stock that you select.

Digital press is another form of offset printing which works well for short runs of 500 or less. This is also available in black and white as well as color.

Composite photos can be reproduced in a flip style which has images on the front and back or your folding style which has images on all four sides of a folded card.

Postcards are another great tool and can be ordered in color or black and white in small quantities at a very reasonable cost. This is something that you can mail out to a prospective client after an audition or to a magazine or an agent to get an appointment. A postcard is also a great way to say "Thank you" or "I'll be in town next week and I'd like to come see you".

You can also order a single image 8" X 10" glossy or matte print in quantities of 50 or more. These are called head shots and are generally used for actors or models who are seeking work in commercials.

Sometimes you may be accepted into an agency if you haven't yet put a portfolio together, by just showing your contactsa contact is a compilation of an entire roll of film on an 8 x 10 card, from which you make your print selections. If you show your contacts, and let your agency choose your prints, it may save you money agencies always like to have the final say on your pictures, and they might be able to get you a discount on your composites.

20

Always Be Prepared–
What's In A Model's Totebag?

This is a question often asked by new models. As a model, you should always be prepared to work. This means keeping a bag packed with all of the essentials necessary for a photoshoot or a fashion show. Some models will carry their "Tote Bags" with them even on go-sees or auditions because you never know when you might get a call from your agency for an immediate booking; and you may not have enough time to go back home for your model's tools.

These are the items which you should keep packed in a backpack or small duffle bag—the "Model's Tote Bag":

o hair brush and comb bobby pins and hair pins
o rubber bands (to pull your hair up)
o head bands (for a sporty look) or (to keep hair off forehead while doing make-up)
o silk scarf (cover your face with this when you are putting on clothes for a fitting or show)
o hair spray
o safety pins and straight pins needle and thread
o scotch tape (removes lint and repairs hems) clear polish (stops a run and brightens nails) nail polish (2 or 3 colors)
o nail file
o crazy glue (in case you break a nail)
o false eyelashes with eyelash glue

o nude pantyhose and off black pantyhose liquid and cream make-up
o translucent powder (loose or compact)
o cosmetic brushes eyeliners
o mascara
o lipsticks (3 or 4)
o lip liners eyeshadows (3 or 4)
o a mirror several
o earings—hoops, buttons, rhinestones, pearls black pumps and beige pumps
o neutral flats
o a light cologne (perfume can be too heavy)
o deodorant
o underarm shields (protect clothing samples)
o razor (for a quick shave)
o small portfolio (a condensed version of your regular one–photos can be 4" x 6")

21

Balancing Your Budget On Your Way To Success

As in any new business, modeling will require a financial investment. After all, you will need to have the proper tools of the trade for your personal promotion. Consider the costs of skin care and make-up products, getting and maintaining a current hairstyle, coordinating a nice wardrobe and the right accessories, dental costs pertaining to clean straight teeth, a photoshoot and the resulting composites and portfolio, costs related to mailing your pictures, competition fees and a travel budget.

Yes, modeling is and should be taken as a serious profession; and should be well planned before you make the investment of time and money. If you know you have what it takes, plan your modeling career properly and give each detail the right amount of attention. After you've read this handbook thoroughly, read it again and take notes. Then sit down and map out a plan. Discuss the details with your parents and be honest about your intentions.

Outline the details of your plan in proper order and proceed step by step. If you encounter a roadblock work around it. Work hard and persevere. After all, you are a winner!

Visiting New York Agencies? Here's a way to save:

If you are planning to visit agencies in New York, you may wish to contact the Gershwin Hotel. The rates are very reasonable at only $39-$59 a night and they have a special dormitory style floor just for models. The hotel features private baths, telephones in each room, 24 hour security, large closets, make-up tables, message board and television. To get a reservation, you must call ahead and give the name of the agency that you will be visiting. The Gershwin Hotel is located close to the garment district at: 7 East 27th Street (between Fifth Avenue and Madison Avenue) in New York City. The phone number is: 212-545-8000, ext. 7342.

Notes

22

Plus Size Models

The plus size woman has become more comfortable with herself and top designers have recognized her buying power. Thus, the "Plus Size" modeling business is increasing at a higher rate than any other market. In this area, there are vast opportunities opening up for fit, runway and print models with the top plus size models earning as much as six figures a year.

As in any other modeling category, however, there are specific guidelines and qualifications necessary to be accepted in an agency and ultimately obtain modeling assignments. Here are some of those specifics:

1. Personality—you should have an extroverted and confident personality. You must enjoy being the center of attention, feel good about your body, have the ability to work with others, be patient, follow directions and project total confidence and poise.

2. Features—You should have attractive features or a striking look. The overall proportion of your face is important. Eyes must sparkle and skin must glow.

3. Age requirements vary depending on the modeling campaign.

4. Modeling Categories include:
 o Print—Models must have a fresh young looking face and know how to work with the camera.

○ Runway—Models have to be comfortable in front of people, have great posture and walk with poise.

○ Fit—Models must fall within the proportions specified by the design houses. The most common size for a Plus-size Fit model, however, is a size 18.

5. Physical requirements for plus size models are similar to any other category in that the model must be well-toned (firm not flabby) and well-proportioned. The favored height requirements are 5'8" to 5'10" and the dress size varies from 12-18 depending on the market you're in.

An important rule of thumb is to remember that you must represent the elite in beauty and health in your age and size range. If you fit the physical requirements of a plus size model, take a new approach toward developing yourself and stay positive and confident about who you are and who you want to be.

23

Children as Models

Most child models get their start because of an observant parent who notices a vibrant personality, a special expression or outgoing friendliness in their child towards other people. In order to become successful as a model, a child must be obviously happy, energetic, disciplined, curious and cooperative. A child who poses every time a camera is near, or sings or dances whenever music plays, or shows off in a new outfit is a great candidate as a model.

Now the question is "how do we get started?" First of all, take note of fast food chains, hair care products, toy companies, clothing stores, and other major outlets that frequently advertise using children on television, newspapers, magazines and billboards. Note the origin and call to get their promotional departments or casting divisions —send a picture. A current snapshot is all a child needs to get started. When you find the right one, make lots of copies and also send them to all of the children's agencies in your city. If you live within two hours of a major city—New York City, Los Angeles, Chicago, Dallas, Miami—then send pictures to agencies in those cities as well.

Don't be lured in by small agency newspaper ads that are looking for inexperienced children and offering large salaries for modeling. Most of those agencies have no proven track record and are not making money for booking children; they survive on the money they earn taking expensive and often useless photos of novices. Avoid "package deals" unless you're just interested in a hobby and spending money is no object. Legitimate agents don't have to advertise for models and

they do not offer you photos or insist that you get them before they can send you on a "go-see".

If an agency is interested in a particular child, they will call you in for an interview. This is the child's opportunity to shine–to make a great impression. Once an agency accepts your child, they will recommend that you work on getting a nice professional photo. The pictures that you use should be black and white–one good headshot will do, but if you wish, you can get a full length picture as well and make a composite. For children, you shouldn't invest a lot of money taking pictures to build a portfolio because their looks change so rapidly (You may need new headshots every six months). A child's portfolio should consist primarily of tearsheets (ads that they have done).

Another great way for a child to break into modeling is by entering live competitions or photo mail-in contests. These avenues will test your child's interest. You should never force your child to model —they have to want it for themselves or it won't work out. Some children lead their parents through the door–if this is their forté, they will let you know.

There are many avenues open to child models, such as:

Editorial
Magazines run stories which may include information about children or public service messages. Many types of children are hired for this category of work. This doesn't pay as well as the other categories, but the exposure is great.

Fashion Print
Children's clothing ads appear in newspapers, magazines, catalogs and on billboards. The most popular sizes for children are 12 months, size 5, and size 10—although they may range from 12-24 months for babies and 2-12 for children. This pays well and the work is very repetitive if the designer likes your child.

Television Commercials

There is no limit to the work that may occur from a casting director who gets the most out of your child. The more natural your child can act, the better. The residuals from commercials are great!

National Advertisement

This is generally classified as print. Acting is involved here, but again, natural is best. The pay is very good for this type of work, but there are no residuals.

Most of the rules for child models are very similar to those of teens and adults, regarding the contract, the vouchers, work ethics, etc.

Part III:

Extra Elements for Your Successful Modeling Career

A Word About Fashion Show Commentary & Coordination

FASHION COMMENTARY is a great way for you to become known in your community. It might be necessary to volunteer your services at first, but as your skills improve you might come into demand.

As a model, you should already be familiar with the newest styles and the fashion terms used to describe them. Because you have modeled to the beat of many fashion commentators, you have probably determined which interpretive style is the most exciting and brings out your best. A commentator is key in helping the model to bring out the best in the fashions that he or she is wearing. As a commentator, you should always be aware of who is on the stage or runway and how that person moves. Every detail of the clothing should be noted, including the style, the color, the fabric, the price and the sizes. It's also a good idea to be able to describe the accessories which are worn with the garments.

Commentating should come naturally to you, as a relaxed attitude on the stage can give you a wonderful presence. Your knowledge of current affairs, particularly relating to the world of fashion and beauty, a great smile and a good sense of humor can be extremely important. You should have a good command of the language, a clear and concise voice, good pronunciation, good speech habits and the ability to adlib. There may be times when you have to talk excessively to fill in for an empty stage or introduce celebrities in the audience. Your appearance,

of course, must be impeccable and your look should follow the theme of the fashion show.

So, whether you want to take a break from modeling or just add another element to you exciting fashion career, commentating can take you into a new world.

FASHION COORDINATION IS AN ART. You can study for this as a career, but you must have a natural feel for this and be able to pull together many elements with ease, to make a fashion show exciting and successful. The fashion coordinator must work with the model to make sure that he or she fully understands the presentation at hand.

The coordinator will also select the appropriate make-up artist, hair stylist, dressers and stage assistants, music and fashion commentator, so that the show runs smoothly. Sometimes the coordinator will even assist the designer in selecting the models for a show. As a model, you will rely heavily on the coordinator to put together a line up that gives you enough time in between outfits to change and be back on stage in time for your next cue.

Your relationship with the coordinator should be built around comfort and trust because your performance will be judged by the outcome of your personal presentation. If you choose to become a coordinator, as a model, you will have been very well trained and you'll understand completely how the models that you are working with should behave and be treated.

If coordinating is something that interests you, be sure to observe all the elements that go into the shows that you're in, take great notes, study and volunteer to help out from time to time. It will all come together and your step into this arena will be very challenging and full of excitement.

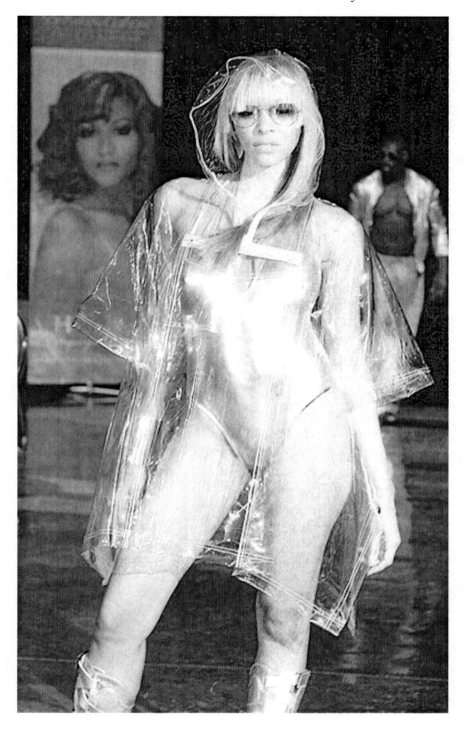

Videos Can Make You a Star

Video Visibility

There are many opportunities in the world of videos. It's always good to practice at home before you go out to audition. If your family or friends have a video camera, the work is easy. Practice the qualities important for modeling—walking straight and tall, sitting with poise, standing properly, having good eye contact with the camera, and speaking fluently. The more polished you are, the easier it will be to get video modeling assignments, so practice consistently.

Keep your ears open for volunteer work with videos such as appearing in a public announcement. This can be a great step up for giving you instant visibility and it will certainly look great on your resume. You should also be on the lookout for talent auditions for local television commercials, cable talk shows, educational videos and demonstration tapes for exercise equipment and other easy to sell items.

If you live in or near a city that caters to the recording industry, watch the papers for music video casting notices. You may be able to start out in the background as an "extra" and work your way into a feature role in a music video for singers and rappers.

Once you're comfortable with video appearances, you should be ready to audition for and win television commercials and movies.

What to Look for in Beauty Pageants and Model Searches

Competitions Can Pay Off

They might be called beauty pageants, modeling competitions or models searches. Whatever you know them as, it all adds up to "stepping into the spotlight". Whether you win or not, this type of visibility can launch you in the world of modeling. Being seen by leaders of the fashion and beauty industry can make a real difference and propel your career forward.

Before you make the decision to compete, check out the history of the pageant. Some of them can be very costly and you want to make sure that it's worth the time and money that you put into it. The judges should be credible and actively involved in either the fashion, beauty or advertising industry. And, there should be some form of media present so that you can receive publicity, especially if you do win.

A lot of competitions conduct seminars in conjunction with the event. This can be a great forum for you to learn more about the business, but if the costs are significantly high because of the seminars, it might be a good idea to pass it up.

Modeling experience is not necessary for you to be a winner. The criteria that a judge looks for are exceptional: personality, figure or physique, speech marketability, posture, poise and facial features. Because of the diversity of judges, there may be a number of favorite contestants. So, even if you don't win you could be selected to represent a product or a line of clothing. The best part about a model's search is the competition. It is a prime example of what can occur in the real world of modeling on go-sees or auditions; and it teaches you how to accept both criticism and compliments.

Good luck! Go with confidence and you'll be a winner.

Below is a list of competitions which can give your career a great boost. We've highlighted a few so that you can become familiar with the criteria.

One of the largest black modeling competitions in the world is **Linden New Day Associates National Models of the Year Award Show**, founded in 1980 by the organization's President John Blassingame. The competition which showcases some of the brightest male and female models on the scene has become the forum for the discovery of some of the industry's leading new faces. The judges are selected from all aspects of the media including editors and publishers of some of the leading fashion and beauty magazines as well as agents, designers and advertising industry personalities. The winner gets an all expenses paid trip to his or her choice of London, Paris or Milan and an opportunity to visit that country's top modeling agencies. For information, contact:

> **Linden New Day Associates**
> P.O. Box 1041
> Linden, NJ 07036
> 609-655-3667
> info@lindennewday.com
> www.lindennewday.com

MB Model & Talent Expo is the brainchild of Mike Beaty, a former agency director. The format is unique to the model and talent industry in that it gives models the opportunity to showcase their talents to the top national and international agents, scouts and personal managers, who come from Greece, Australia, Spain, Germany, England, Italy, France, Japan, Taiwan and, of course the U.S. The three day weekend event consists of a series of seminars as well as a variety of competitions in photography, runway and television commercials. This expo is not only an exciting event but it is extremely affordable. For information, contact:

MB Model and Talent Expo
mike@modelandtalentexpo.com
www.midlandtalentexpo.com

America's Next Top Model (often abbreviated as ANTM) is a reality television show in which a number of women compete for the title of America's Next Top Model and a chance to start their career in the modeling industry. Tyra Bank's hit show casts nationwide and comes to dozens of cities and small towns all across America. Typically, the ANTM casting calls go on all through the month of February. Visit: http://www.cwtv.com/shows/americas-next-top-model for further information.

Other modeling and talent competitions which you might want to check out are:

Model Search America
1221 Brickell Avenue
Suite 900
Miami, FL 33131
877-633-3130
info@modelsearchamerica.com
www.modelsearchamerica.com

Miss Black USA Pageant, Inc.
12138 Central Ave., Suite 343
Michelleville, MD 20721
866-692-1659
info@missblackusa.org
www.missblackusa.org

IMTA (International Models & Talent Association)
www.imta.com

Super Models of the Year
Ford Models
111 Fifth Avenue
New York, NY 10003
212-219-6500
www.fordmodels.com

Wilhelmina Teen Search Contest
300 Park Avenue South
New York, NY 10010
212-473-0700
www.wilhelmina.com

Miss America Pageant
The Miss America Organization
222 New Road – Suite 700
Linwood, NJ 08221
609-653-8700
info@missamerica.org

Miss Teen USA Pageant
The Miss Universe Organization
1370 Avenue of the Americas, 16th Floor
New York, NY 10019
212-373-4999
PR@missuniverse.com
www.missuniverse.com

Miss USA Pageant
The Miss Universe Organization
1370 Avenue of the Americas, 16th Floor
New York, NY 10019
212-373-4999
PR@missuniverse.com
www.missuniverse.com

Miss Universe Pageant
The Miss Universe Organization
1370 Avenue of the Americas, 16th Floor
New York, NY 10019
212-373-4999
PR@missuniverse.com
www.missuniverse.com

Samples For Models Search

Rules & Regulations:

This model search program is open to assertive models eager to get ahead and have a more fulfilling and successful modeling career. There is an application fee. To enter this models search program, you must be

100% committed to fulfill all requirements of the producers in order to benefit fully in your modeling career.

1. Age requirements: Open to ages 12 to 22 years, male and female.

2. Models must be single and aspiring to move up the ladder of success and willing to invest the time and effort necessary to achieve your goals through a professional appearance.

3. As each model develops his/her stage presence he/she will have a greater power of persuasion and influence on people. Each participant is responsible for motivating and making arrangements for 10 paid guests to attend the model search. The more guests you have attending the competition to applaud your performance, the more confidence you will have in front of the judges.

4. Models are required to pass an initial readiness screening before acceptance into the program.

5. Models must attend rehearsals and any special activities needed in preparation for professional production finals.

6. If any model declared winner in the finals is disqualified, the next qualified participant will be declared the winner. Participants disqualified must return all gifts and awards to management.

7. Models must submit with application a recent photograph. Said photographs are not returnable. Also required is a typed updated resume.

8. The model's showcase management reserves all rights to disqualify any model who fails to abide by the above rules and regulations or whose deportment is deemed unsatisfactory image-wise, morally and unacceptable according to the basic etiquette standards.

I understand and accept the above rules and regulations:

Signed_____ Date:_____

Sample Prizes for Models Search

Winner:
- o 1 year contract with agency
- o Scholarship to modeling school
- o Cash prize
- o Photo session with fashion photographer for portfolio
- o Professional make-up artist & hairstylist for photo session
- o Model's portfolio

1st Runner-up:
- o 6 months contract to agency
- o Free seminar in skin care & make-up
- o Free seminar on how to be a successful model

Sample Cover Letter to Modeling Agencies

Notes:

o Before you mail out your photos, call the agency to see if they accept them.

o Use this letter as a guide when you are sending out pictures to modeling agencies.

o Always include your statistics and experience (if any).

o If you can't have professional pictures, send snapshots.

o Be sure to include your phone number and address.

o Set up a personal message service or voicemail.

Your Name
Your Address

Today's Date

Ms. Bea Beautiful
Chic & Trendy Agency
1234 Fifth Street
Fashion City, NY 67890

Dear Ms. Beautiful:

I am writing to introduce myself to your agency. I understand that you have specific requirements for your new models and I feel that I meet those requirements. I am 15 years old, 5'9" tall and I weigh 110 pounds. My experience consists of runway modeling at a few local fashion shows.

Please find enclosed two photos (a fashion shot and a headshot). Once you've had a chance to review the photos, I would like to come in to your agency for an appointment. I have high aspirations in becoming a very successful model. I am looking forward to hearing from you. I can be reached at (123) 456-7890 or you may write to: 16 NW Dawson Street, Your City, Your State 12345.

Sincerely,

Your Name

Sample Resume:

YVONNE ROSE

Agency:	586-7263	AFTRA
Service:	799-9099	
Height:	5'8" Weight:	120
Eyes:	Hazel	
Hair:	Auburn	

TELEVISION:
"Good Day Show" - WCVB - Boston
"Night Scene" - WNAC - Boston
"Say Brother" - WGBH - Boston
"Sunday, Sunday" - WJAR - Providence
"Good Morning Bermuda" - ZFB - Bermuda
"Ellerbee's Eye on Fashion" - Cable - Newark
"Midday Live" - ABC - New York
"Ryan's Hope" - ABC - New York

FILMS:
"The Verdict" - MGM - Airline Passenger
"Hanky Panky" - Columbia - Business Woman, Shopper
"Yes, Georgio" - Paramount - Party Guest
"Parole" WCVB-TV (Boston) - Nightclub Patron
"Terror Eyes" - Universal - Spectator, Customer
"How to be Effective" - Cablevision - Feature
"Boomerang" - Paramount - Restaurant Patron
"Malcolm X" - Universal - Pedestrian

RADIO:
"The Fashion Scene" - WILD (Boston) - Host/Producer
"Inner City Beat" - WRKO (Boston) - Special Guest
"Lee Harvey Show" - ZFB (Bermuda) - Special Guest

COMMERCIALS PRINT ADVERTISING AND MUSIC VIDEOS:
Numerous accounts–List on request includes: Dark and Lovely, Tampax, Essence, Fashion Fair Cosmetics, Canadian Club and Atlantic Records

SPECIALTIES:
Runway Modeling, Public Speaker/Commentator, Roller Skating, Dancing, Bicycling, Bowling, Billiards, Modeling, Show Host, Publicity/Promotions, Make-up Artistry, Hairstyling, Typing, Computer Operator, Licensed Driver

Model Agency Sample Contract

This Modeling Contract entered into on this _____ day of _____, 19___, by and between "XYZ" Agency, having its principal place of business at "Any Street, NYC" and "You" residing at "Your Avenue, USA".

1. I, the model hereby employ XYZ Agency to secure modeling and acting assignments in the area of live fashion shows, print advertisements, television commercials and other forms of electronic media and promotional work.

2. In consideration for the Agency's agreement to manage my career, I the undersigned, hereby employ you to act as my exclusive manager to direct my career as a model only and agree to accept from you for my services a gross sum equal to 80% of all monies received as a result of contracts made during the term of this contract.

3. The terms of this contract are for one (1) year from the date executed below. The contract is automatically renewed each year thereafter unless written notice is given to the agency from me terminating this contract.

4. You are hereby appointed by lawful attorney in fact with full authority to demand, collect and receive in my name, all payments, whether by cash, check or otherwise, to which I may become entitled: to make, execute and deliver receipts; and endorse, deposit and collect any check, note, draft or other instrument for the payment of monies that may be payable to my order, and to sign photographic releases and to do and perform any matter or thing whatsoever for and on behalf and in my name, all in connection with my services in the field covered by this agreement.

5. It is agreed that you will pay me a gross amount of 80% of the face amount of my signed vouchers, and in the event you are unable to collect said amount from the client, I agree that I will suffer the loss. This guarantees against loss of course, and does not cover legitimate client disputes or adjustments.

6. It is agreed that on all AFTRA, SAG and EQUITY employment, the commission of 10% will be paid to the Agency.

7. In consideration of payments to be made by the Agency to me, I hereby agree that you own the proceeds of the modeling assignments against which payments are made.

8. You are hereby authorized to use my name, portrait and pictures to advertise and publicize me in connection with your representation of me.

The parties hereto have executed this agreement the ___ day of ___, 19__.

Model's Signature _____

Agent's Signature _____

Sample Model's Release

Date: _____ Telephone: (_____) _____
Name: _____
Address: _____

I hereby give XYZ Publications the absolute right and permission to copyright and/or publish, or use photographic portraits or pictures of me, or in which I may be included in whole or in part, or composite or distorted in character or form, in conjunction with my own or a fictitious name, or reproductions thereof in color or otherwise.

I hereby waive any rights that I may have to inspect and/or approve the finished product or printed matter that may be used in connection therewith, or the use to which it may be applied.

I hereby release, discharge, and agree to save XYZ Publications from any liability by virtue of blurring, distortion, alteration, optical illusion, or use in composite form whether intentional or otherwise, that may occur or be produced in the taking of said pictures or in any processing tending towards the completion of the finished product, or its publication or distribution.

I hereby represent that I am over the age of 18 years and I have read this authorization and release prior to its execution.

Model's Signature _____

Witness _____

For all reproduction rights to the above-mentioned photographs photographed on this day and/or editorial material in any issue of any publication of XYZ Magazine.

Unions

Generally, in order to work in films, television shows, videos, commercials and radio programs, you must be a member of a union. There are two specific unions that a model might wish to be affiliated with—AFTRA (American Federation of Television and Radio Artists) and SAG (Screen Actors' Guild). Both unions will serve to protect you as a "talent" with respect to the amount of money you earn, the hours that you work in a day or the days in a week, and the location of your booking.

You can join AFTRA at any stage of your career and it is highly recommended if you wish to work in the television or radio industry. This union does not find you jobs. They will protect a member's rights by negotiating contracts, setting minimum wages and monitoring working conditions. It is an open union. Anyone can join this union if they have an aspiration to work in the industry. For more information, talk to your agent or contact the Membership Department of AFTRA directly at:

AFTRA or
260 Madison Ave.
New York, NY 10016
(212) 532-0800
www.aftra.com

AFTRA
5757 Wilshire Blvd., 9th Floor
Los Angeles, CA 90036
(323) 634-8100

SAG will also protect a member's rights by negotiating contracts, investigating harassment claims, setting minimum wages and monitoring working conditions and on the set safety.

To be eligible to join SAG, you must meet one of the following criteria:

1) You must have been employed under a SAG contract in a principal or speaking role.

2) You must have been a member of a union such as AFTRA for at least one year; and you must have worked (have a speaking part) at least once as a principal performer in a feature film or commercial and be a paid up member.

3) You must work for at least 3 days as an "extra" in a SAG covered film.

Once you have completed either of the above criteria, you will be eligible to apply to SAG for membership. If you wish to work in films, keep your eye out for a role as an "extra" and maintain as much visibility as possible on the set. Sometimes, you may be fortunate enough to be moved up into a speaking role (one or two lines is all you need) or you may be booked for more days (3 days will make you eligible).

To learn more about SAG, write or call to Membership Department:

SAG or
360 Madison Ave.
12th Floor
New York, NY 10017
(212) 944-1030
www.sag.org

SAG
5757 Wilshire Boulevard
7th Floor
Los Angeles, CA 90036
(323) 954-1600

The Model's Quiz

Now that you know modeling is for you, you're ready to hit the pavement and find the modeling agency that's best for your new and exciting career. Before you do that, and before you turn the page and start looking at all of the wonderful agencies that are there in your area, let's have some fun and fill in the blanks to these very important statements and questions. The answers can be found in Chapters 1, 2, 3, and 4.

1. _____ can be a full-time career which requires a lot of hard work.

2. Models are sometimes referred to as _____ because of their versatility and ability to change.

3. Key essentials for successful models are _____ , even white teeth, well-groomed hair, a good firm and slender body, the right height and a photogenic face.

4. You'll get helped along the way by hair stylists, _____ and other fashion industry professionals hired by the client.

5. Can you _____ and dress into an entire outfit in one minute?

6. Would you work out _____ hours a day to stay thin and in shape?

7. If a model doesn't work for _____ consecutive months, your agency has an option to drop you.

8. A top _____ does not require that you have modeling experience.

9. Weight must always be in _____ to height.

10. If you are a new and inexperienced model, say so; and allow the agency to _____ you.

11. When scouting for an agency contract, take your best _____ with you.

12. Your _____ will play only a small part in the agency's final decision.

13. Be cautious about _____ contract's. Shop around first.

14. You should never have to _____to join an agency.

15. Modeling is a serious career or profession and should be considered just like any other business that requires _____, dedication and determination to succeed.

16. The agency is usually a key component to your _____ in the modeling career.

17. You might compare a modeling agency to a _____ center.

18. The primary focus of the modeling agency is similar to that of a
_____.

19. Once or twice a year, agencies compile a _____ or book of pictures of their models and use them to _____ them to perspective clients.

20. A model may be booked to photograph for newspapers, magazines and
_____ .

21. If a client sees a model which they think they can use, they call
the _____and request the _____and/
or they ask to meet the model in person. This meeting is called a
_____ and it is arranged by the agency.

22. If you are on hold for an assignment and the assignment cancels or is postponed, you will be entitled to a _____ payment from the client.

23. Once your agency sees the _____ for you in a specific category, it becomes easier to _____ you and escalate your career as a top model.

24. When a model doesn't work, neither the _____ nor the
_____ gets paid.

25. Most agents charge the models _____ or
_____.

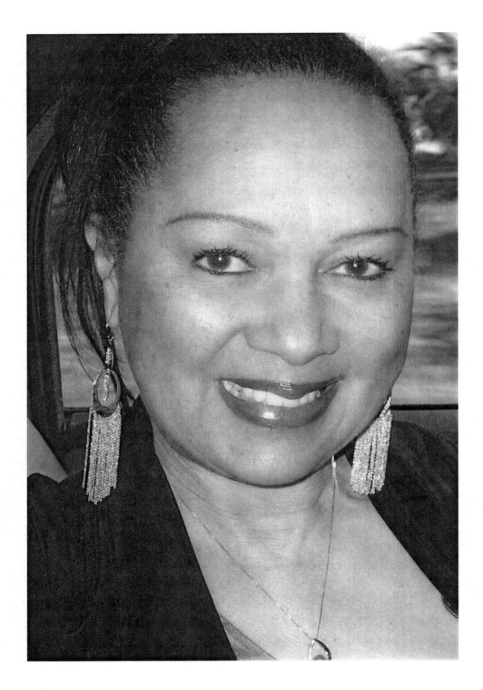

In Conclusion—Let's Keep In Touch

Print Modeling pays extremely well, especially catalog and major product (beauty) contracts.

The best way to break in is through magazine editorials, but they give you the exposure more than the dollars. The agency is your contact for print work, if you are marketable in the fashion world.

Commercial/Television Modeling is a little less stringent with its rules. The height and beauty requirements are more flexible . . . however you must have acting abilities. Study if it's what you want!

Also develop any other talents that you might have, such as swimming, horseback riding, singing, dancing and skating, so that you will be even more marketable. You should also build up a strong resume and be involved in as many activities as you can, so that you can sell yourself through your qualifications as well as through your skills.

If print or Commercial/Television Modeling are not your forte, perhaps it's runway, showroom, fit or trade show modeling. If you have the size requirements and the drive, there is an area for you to work in. If modeling is for you; work at it, be consistent, treat it as a business and don't give up! I believe in you. You believe in yourself. I look forward to seeing your smile on the cover and on the runway.

Good luck! God bless!

…..and write me.	C/O Amber Books
	1334 E. Chandler Boulevard
Fashionably yours,	Suite 5-D67
	Phoenix, AZ 85048
Yvonne Rose	amberbks@aol.com

Glossary

The following is a listing of terms used in association with modeling:

Abroad—Places outside of the United States where you can go to model, such as London, Paris, Milan and Tokyo.

Accessories—Fashionable items that you wear to complement your clothing, such as jewelry, belts, pocketbooks, hats and scarves.

Advance—A sum of money paid to you by your agent on behalf of an advertising company that wishes to book you for a job. This is usually paid in advance of your working to secure your services particularly if you are in demand as a top model.

Advertising—The action of getting the word out or letting the public know about a product or service.

AFTRA—American Federation of Television and Radio Artists is a union for performers which establishes specific fees for different types of performances and protects the model's or actor's rights. **Age Range**—The ages that a model can portray (usually a 5 to 7 year span).

Agency—An establishment that does business on behalf of the model, such as booking jobs and collecting payment for the model for a specific fee (usually 15-20% of dollar amount collected). **Agent**—A person who works for an agency or who has a privately held business to book models.

Appointment Book—A calendar or date book used to record bookings, go-sees or anyother business activities. You may also use this book to keep a record of your expenses for tax purposes.

Assignment—This is the same thing as a booking or modeling job whereby a model is paid for services performed—runway, print, trade shows and other types of employment associated with modeling.

Audition—This is a trial performance which is given to show the casting directors how well you are qualified for the job.

Beauty—The qualities of a person that are pleasing to the viewer's eyes.

Beauty Shots—Pictures that are taken from the shoulders up, featuring the hair, the skin, the eyes, the smile and the makeup. Also known as head shots.

Black and White Photo—A picture that is taken specifically to produce black, white and grey images. Usually black and white photos are suggested for head shots.

Book—This has two meanings: To book means to assign or a book can mean a model's portfolio.

Booker—A person who gets jobs for models; the same as an agent.

Booking—This is an assignment.

Buy-out—When a client arranges a one-time payment or flat fee for a commercial instead of paying residuals for the job. This means that you will not get paid every time the commercial plays—the fee should be quite substantial.

Call Back—When you go on an audition and the casting director likes your performance and wants to see you again.

Career—This is a profession which you have trained for and intend to stay with for a period of time.

Carriage—The way a model carries herself or walks.

Casting—The act of choosing a suitable model for a particular assignment.

Casting Director—The person who works with advertising agencies to select the talent for a particular modeling job.

Catalog Work—Modeling for photographs which will be used in catalogs produced by a manufacturer or distributor to sell clothing or other items.

Cattle Call—This is a type of audition where hundreds of models will show up to be viewed by casting directors or photographers. Usually new models are sent by their agents so that they can be introduced.

Celebrity Model—A model who has become top in the field and who earns very high salaries. Also referred to as a "Top Model" or "Superstar".

Character Model—A model who is not necessarily a beauty, but who may have strong interesting facial features and selling attributes for specific products.

Checklist—A notebook which is referred to daily where you list all of your "things to do".

Child Model—A young model (usually between the ages of 2 and 12) who promotes products such as toys, clothes and food in ads and on television.

Client—A person or company who a model actually works for and who pays the costs for advertising or production.

Commentary — A dialogue or script that explains the fashions being presented at a show.

Commentator—The person who gives the commentary at a show.

Commercial —An advertisement which is broadcast on radio or shown on television.

Commercial Look—A look that is appealing to the targeted audience. Usually this is someone that they can identify of the same age or ethnic background.

Commercial Model—A model that sells products that are generally purchased by their targeted audience. Fashions are not sold by this type of model.

Commissions—A percentage of the total amount of money paid to an agent on behalf of a model.

Competition—A contest between rivals or a term used to describe models who are just like you and working in the same market.

Composite—A photo card which is comprised of several different pictures of a model (usually 2-5 poses). This card can be produced in either 6 X 8 or 8 X 10 inch formats and should contain at least one head shot and different poses which show your best physical attributes.

Contact Sheet—This is a photo which includes all of the shots from one roll of film. (Each image is the size of a negative and should be viewed through a loupe or magnifying glass) It is printed so that the model can compare the slight differences in the poses and angles and select the best ones for the portfolio or composites.

Contract—A binding agreement which outlines specific terms and performance guidelines between two or more parties, such as an agent and model or model and client.

Coordinator—A person who brings together all of the aspects associated with a specific production, such as the hiring of models and the selection of location and production staff. The coordinator's tasks begin when the production is developed and ends at the completion of the project.

Day Rate—This is the amount of money paid to a model for one day regardless of how many hours that model works. The time, however should not exceed eight hours.

Demonstration—This is the act of showing an audience how a product works.

Dermatologist—A professional person who deals with skin disorders.

Designer—A person who conceives and creates fashions or other unique items.

Director—The person who supervises or oversees the production of a show. This person is responsible for the flow of the show and makes the decisions about lighting, staging and the overall presentation.

Dressers—The people who work back stage at a fashion show to help the models with quick changes by having the garments ready for them and helping them with buttons or zippers. They also keep the dressing room neat by hanging garments after they are worn.

Dry Skin—Sometimes dry skin is tight or itchy and it may appear dull. Be sure to cleanse with a cream or lotion (soap may dry your skin even more) and always use a moisturizer.

Editorial Print—These are pages in a magazine which tell a story or idea and where a model might be presented in a role that complements the storyline. There is the opportunity for a variety of models to work in this category from fashion to general or commercial looks.

Electronic Media—This is generally related to sounds or images that are made for the purpose of selling a product or idea. They can be presented live on radio and television or in video, film and slides productions.

Esthetician—A trained skin specialist who works to enhance the skin by using certain products and special massage techniques.

Exclusive —This means that you can work for only one specific agent or group because of contractual obligations.

Exposure—This term is used in relation to a section of film, such as the number of exposures; or it can mean the amount of publicity a model receives from ads, commercials, promotions or public relations.

Expenses—The amount of money that you spend on items or travel related to your work as a model.

Extras—These are models that are hired to work in the background on a movie or video production.

Facial Features—This could be your bone structure or cheekbones, your lips, nose or eyes. These are viewed most often by clients in the hair or cosmetic industry.

Fashion Model—This is a model who meets the specific size and height requirements to model designs in live fashion presentations or fashion layouts in newspapers and magazines.

Fashion Photographer—This is a professional photographer who specializes in photographing fashion models.

Fashion Shot — This is a picture that specifically captures the details of your outfit and features you from head to toe. This type of picture is a must for your composite if you are a fashion model.

Fee—The rate of pay that an agent will charge the client for booking you. This can be an hourly rate or a daily rate.

Fit Model—A model with standard proportions who tries on newly manufactured clothes before they are presented in a show or layout.

Flat Fee—A set amount of money that has been negotiated for a particular job.

Formal Fashion Show—A formatted fashion show which takes place on a runway, stage or other locations that can house an audience.

Format—A specific arrangement or plan for a presentation.

Garment District—The area in a city which houses a majority of fashion designers and manufacturers, such as New York's Seventh Avenue (also known as Fashion Ave.).

Glossy—The type of finish on a professional photo which is most commonly used for head shots. A glossy can be ordered in quantities of 50 and sent out to casting directors or agents with a resume attached for the purpose of getting booked for commercials or films.

Hairdresser—The person who cuts, colors and styles your hair on a regular basis or on the set of a job.

Handbook—A book that gives you knowledge about or guides you through a successful career.

Hand Model—A person who works in print or commercial jobs that photograph just your hand. For instance, a model with long slender hands which are well groomed should take a few photos of the hands holding different products.

Headsheet—This is a poster or a book produced by an agent which includes pictures of several of the agency's models. The agency mails the headsheet to prospective clients as a form of advertising for the agency's models.

High Fashion—This is a term used regarding the best of the current fashion trends.

Highlight—To highlight is to bring out, enhance or feature something or someone. This is also a term used in make-up where you blend in lighter shades to add balance to your features.

House Model—A model who works for a specific designer modeling within the design studio.

Illustration Model—A model who poses for an illustrator or artist wearing designs that will be featured in fashion ad layouts. Sometimes the sketch is done from a photograph.

Image—What you present as a complete or total look or fashion statement.

Informal Modeling—A style of modeling that is done by walking through a department store, a tearoom or a restaurant. It is casual and very friendly as you are close to your audience.

Interview—A meeting at which information is obtained, usually between a model and an agent or client.

Junior Model—This is a term used for models with a young look or who wear junior sizes. The size in demand is usually junior size 3-7 and the weight is about 95 to 100 pounds.

Makeup Kit—Usually a plastic cosmetic bag or tote to carry all of the glamour essentials.

Layout—The way photos and words are positioned in an ad to make it appealing.

Leg Model —A model who has well-proportioned legs and who models stockings and beauty lotions or products specifically made for the legs.

Live Promotion—A trade show or other event where a model may demonstrate products or hand out samples or flyers for a specific client.

Location—An area outside of the studio where you go to take pictures, such as a beach, a vehicle or a specific building, street, or country.

Loupe —A circular-shaped magnifying glass used to enlarge the view of composites so that you can see all details of the shot.

Madison Avenue—A well-known street in New York that houses many top advertising agencies.

Mailing List—A very important list of names and addresses that a model should have to send composites to on a regular basis. Even if you have an agent, you should continue to promote yourself until you become a top model by mailing to ad agencies, manufacturers, designers, catalogues and department stores. You can get these lists through label houses or through resource books—many are available at the "Models Mart" in New York City.

Major Markets—These are cities that, because of their large populations, pay the most money for commercials and advertising. Great areas to launch a successful modeling career are New York City, Chicago, Miami, Los Angeles and Dallas.

Make-up Artist —This is a person who applies make up professionally to models and other people before they appear on television, in films or any other public platform.

Male Model—A man who models designer fashions and who wears a size 40R with a 6' height.

Mannequin—Another word used for a fashion model. It is also a style of modeling in which the live model appears to be inanimate.

Market—An area that is frequented by models for fashion work.

Model—A person who works in the field of fashion to wear clothes for viewing or who demonstrates or displays other items for consumer interest.

Model Agency—An agency that specifically finds work for models.

Model's Release—A form that a model signs granting the rights to a photographer to publish her pictures.

Negatives—The images necessary to produce pictures after a film has been processed.

New York City—It's a city alive with fashion—housing designers, photographers, models, advertising agents and Manhattan—and is known as the modeling capital of the world.

Oily Skin—This type of skin requires drying products to reduce the oiliness. Products are available for this and to help in reducing the pores which are usually enlarged.

Original—The first of its kind to be made as in a designer's sample garment.

Overtime—Any time that you may work after an eight hour day, after hours, on Sundays or on Holidays.

Parts Model—A person who models, hands, legs, feet or any other part of the body specifically.

Personality—The characteristics or traits that make a person unique.

Petite Model —A model who is under 5'6" and who wears sizes under a 6.

Plus Size Model—A model who wears size 12 and above.

Photo Session—The time a model spends taking pictures.

Photographer—A person who takes pictures professionally of people, places and things.

Photography Assignment—A paying job for a model to take pictures for a specific layout.

Platform Model—A model who appears on stage in a demonstration for beauty or hair techniques or on behalf of new products that may be introduced.

Portfolio—A presentation book with a model's best pictures and tearsheets used to show prospective clients how you photograph.

Pose—A specific way a model might stand in front of a camera.

Poster—An enlargement of a photo (with or without printing) used to advertise a product or service. This can be a great way for a model to get visibility.

Posture—This is noted in models by the way they stand. The position of the shoulders and control of the stomach, the buttocks and the pelvis are important to a model's good posture.

Potential—Something that can develop or happen successfully in your behalf.

Presentation—The act of presenting or showing something in a formal manner.

Print Model —A model who is photographed regularly for catalogues, newspapers, magazines, billboards and other advertising announcement forms.

Product Demonstration—The act of showing how a product works either live, in front of a group of people, or on film or video.

Professional—A person who participates in a given occupation over a period of time and makes it a career.

Promotional—An event or task which is used to increase visibility of a specific fashion, style, product or service.

Proof—This is the same as a contact sheet.

Public Relations —A business whereby the public is introduced favorably to something new or pre-existing.

Publicity—An act or service devised to call attention to someone or something, usually through print or electronic media.

Quality—A specific feature by which a person's actions are measured.

Rate—The amount of money agreed on for a specific assignment.

Reading—The term used when you are auditioning for the purpose of "reading" the script. Your agent may ask "How was your reading?"

Reshoot—You may be asked to come back and be photographed a second time for a job because of problems that may have occurred or changes requested by the client. You should be paid for this at the same rate as the original shoot unless a new rate has been negotiated.

Residual—This is an additional form of payment which you will receive for a commercial which airs more than the number of times stated in your original contract.

Resume—This is a background information sheet on all of the work that a model has done.

Rounds—This is a term used by models when they go from place to place to introduce themselves, leave a composite and look for work. Usually you work from a list and see photographers, designers and advertising agencies.

Runway—This is the place where you walk when you're giving a live fashion presentation. It is also referred to as a catwalk or ramp and is always elevated above the crowd. A runway can be shaped like a "T", an "L" or a straight line.

SAG—The Screen Actors' Guild is a union which protects an actor's rights while working on a film. In order to become a SAG member you must have been hired for a position and you must pay a specific fee.

Sample—This is the first garment or original garment made by a designer which is then used to fit, to show, and to copy from.

Sample Size—This is the size that the designer cuts his or her garments in. There are different sizes for each type of modeling—such as junior, petite, plus and fashion.

Scheduling—The act of making appointments.

Script—The words that a model must speak for a commercial.

Shoe Model—A female shoe model wears size 6-7 narrow and a male shoe model wears size 10. They model shoes in shows and print display ads.

Showroom—A room in the designer's establishment which is used to show buyers the new fashions.

Showroom Model—A model who works in the showroom so that the buyers can see and order the new fashions.

Slides—This is a special type of 35m film that has been processed into strips, cut and encased in cardboard or plastic. A model can use slides to be reproduced into photos or composites.

Specialty Model—A model who specializes in body parts, such as legs or hands.

Speech—An individual manner or style of speaking.

Spokesperson—A person who speaks publicly about a product or service on behalf of a particular client or cause.

Spread—This can be a photo layout that covers two pages of a magazine, booklet or portfolio.

Statistics—These are the measurements of a male or female and include clothing size and height as well.

Stylist—This is a person who selects accessories to complement the fashions that are going to be worn in a presentation or layout or put on display.

Talent—A special aptitude or artistic ability.

Talent Agent—An agency that books a person as a performer or actor.

Tearsheets—These are pages that a model would tear out of a magazine, featuring actual work. It is essential for a model's growth to collect tear sheets and put them in a portfolio or on a composite.

Test Shoot—A shoot that is mutually agreed on by the model and photographer which results in both parties obtaining pictures for their portfolio. The photographer's fee which should be minimal will be used to cover expenses such as film.

Tools—As in any profession, these are things necessary to do the job such as the portfolio, accessories, shoes and hair pieces.

Totebag—This is the bag that a model uses to carry the necessary tools for the job.

Trade Show—This is an event or convention where products and services are promoted to the industry or the public.

Translucent Powder—A light natural powder that blends in to your skin tone and reduces the shine or oiliness on your face.

Trunk Show—A type of fashion show that's usually held in a store to promote a particular designer. This show travels from city to city and the garments are carried in a trunk.

Type—This can be typical of a group of people that have similar characteristics (the same type).

Typecasting—This is when you get a part in a film or video because of the way you look.

Union—An organization that you can join for a particular cause or purpose.

Video—A version of filming often used in music productions or to promote someone or something.

Voiceover Talent—Someone who has a great speaking voice and speaks on commercials or to explain something happening in a video.

Voucher—A printed form that is filled out after a model has completed a job and presented by the agent to the client for payment. The time worked is logged on this form with the rate of pay and signed by the client and model at the end of the assignment.

Wardrobe—The collection of clothes that you own.

Wholesale—Fashions or products that are sold for less money than regular retail prices in major stores.

About the Authors

Yvonne Rose has modeled professionally throughout the United States and in Europe and is a journalist whose face and writings have graced the pages of numerous publications. She is currently the Associate Publisher of Amber Communications Group, Inc., the Director of Quality Press and the co-author of *Ageless Beauty: The Ultimate Skincare and Makeup Book for Women & Teens of Color*.

Tony Rose is an Entertainment Business Entrepreneur and the Publisher / CEO of Amber Communications Group, Inc., with offices in New York City, Phoenix and Los Angeles.

Is Modeling for You?

Order Form

Fax Orders: 480-283-0991
Telephone Orders: 602-743-7211
Online orders: WWW.AMBERBOOKS.COM
Email: Amberbk@aol.com

Postal Mail Orders: Send Checks & Money Orders
 Payable to Amber Books
 c/o Amber Communications Group, Inc
 1334 East Chandler Boulevard, Suite 5-D67
 Phoenix, AZ 85048

Please send _____ copy/ies of *Is Modeling for You? The Handbook and Guide for the Young Aspiring African American Model* by Yvonne Rose and Tony Rose - $15.95

Please send _____ copy/ies of *Ageless Beauty: The Ultimage Skin Care & Makeup Book for Women & Teens of Color* by Alfred Fornay and Yvonne Rose - $15.95

Please send _____ copy/ies of *Beautiful Black Hair: Real Solutions to Real* Problems by Shamboosie - $16.95

Please send _____ copy/ies of *The Afrocentric Bride: A Styling Guide* by Therez Fleetwood - $16.95

Please send _____ copy/ies of *Born Beautiful: The African American Teenagers Complete Beauty Guide* by Alfred Fornay - $14.95

Please send _____ copy/ies of *The African American Women's Guide to Successful Makeup & Skin Care* by Alfred Fornay - $16.95

Name: _____

Address: _____

City: _____ State: _____ Zip: _____

Phone: (_____)_____ Email: _____

Add $5 shipping per book
Sales tax: Add 7.05% to books shipped to Arizona addresses.

Total enclosed: $_____

Paid by:
❑ Check/Money order
❑ Credit Card #:_____ exp: _____

For Bulk Rates, Call: (602) 743-7211 or email: amberbk@aol.com

CPSIA information can be obtained at www.ICGtesting.com
Printed in the USA
LVOW061428070613

337541LV00012B/251/P